BONNARD

BONNARD

Julian Bell

Φ

Phaidon Press Limited
140 Kensington Church Street, London W8 4BN

First published 1994
© Phaidon Press Limited 1994

A CIP catalogue record for this book is available from the
British Library

ISBN 0 7148 3052 6

Printed in Hong Kong

Cover illustrations:
Front: *Getting Out of the Bath*, c.1926-30. Private collection (Plate 37)
Back: *The Cherry Tart*, 1908. Private collection (Plate 15)
The publishers would like to thank all those museum authorities and
private owners who have kindly allowed works in their possession to
be reproduced.
The author would like to thank Timothy Hyman and Sargy Mann for
affording him some of their deep understanding of this subject.

Bonnard

There is no word for the distinctive quality that memory adds to immediate experience. Scenes or episodes when recollected are steeped in a certain heaviness, a richness – not necessarily nostalgia, not always a sweetness – that was absent from the living of them in the present. This is the quality that Pierre Bonnard gave to what he painted, transmuting it. Pleasure and love, however often they prompt the subjects of his painting, do not account for the residue the painting leaves on the imagination. Bonnard's scope may seem restricted, excluding many of the urgent concerns of the times he lived through; but acquaintance with his 60-year career – some 2,200 paintings, a fat body of graphic work, a great hidden store of drawings – reveals an integrity that holds against the flow of those times, making him one of the most compelling presences in twentieth-century art. His development was steady but circuitous. The aspirations of the milieu which formed him as an artist in the late 1880s were brought to fullness in the 1920s and 1930s, when he was an elderly man working on his own. Throughout his life he was intent and humble about his work and its place in the world, and his greatness as an individual is in this humility.

Pierre Bonnard was born in 1867 at Fontenay-aux-Roses, an outer suburb of Paris. He was the second of three children; his older brother became a chemist and his sister a musician. His father was a head of department at the French War Ministry. A light-hearted life story in pen sketches made by him when he was in his early forties places the artist squarely in a background of cultured bourgeois conventionality: dandled on mother's lap as if for the portrait photographer, pert in a sailor suit, studious in uniform outside a Paris *lycée*. Each summer the family headed south to his father's inherited property at Le Grand-Lemps, a village in the Alpine foothills of the Dauphiné. With its orchards, barns and farm animals, with its big vistas and memories of family picnics, Le Grand-Lemps became Bonnard's first idea of a pastoral idyll. Practically the only writings he ever prepared for publication, near the end of his life, are reminiscences of times spent there; his earliest surviving paintings, made when he was 19 or 20, are views of the surrounding region. They are fresh, able exercises in open-air observation, suggesting that he had been looking at the landscapes of Jean-Baptiste-Camille Corot (1796–1875).

Bonnard enrolled for evening classes at the Paris art schools known as the Académie Julian in 1887, his days at this time being spent studying for the law. The artistic scene he came upon in these lively, undisciplined studios had seen a revolution come and pass since the heyday of naturalist painting such as Corot's in the 1850s. The Impressionists – among them Claude Monet (1840–1926), Camille Pissarro (1830–1903), Auguste Renoir (1840–1916) – had already become a senior generation, if not yet as terminally respectable as the academicians of the Salon they had contended with.

The dominant mood of younger artists reacted against Impressionist

art with its basis in observable appearances, facts of visibility. Writers had led this reaction. Appearances, according to the poet Jean Moréas in his *Manifeste du Symbolisme* of 1886, should be mere clothing, subordinate though necessary, for 'the Idea'; the philosophy of Henri Bergson promised a way of surpassing the immediate fact, enveloping it in the flow of memory and feeling; and the wrought subtleties of Stéphane Mallarmé's poetry, with their appeal to analogical, symbolical ways of thinking, stood as a touchstone for a generation 'tired of the quotidian', in Gustave Kahn's phrase. The 'Idea', to judge at least from the buzzing diversity of appearances left by artists of the period, might include whatever transcended that 'quotidian'. It could entail scientistic theories, anarchist politics, esoteric religion or exotic cultural forms ranging from Scandinavian drama to oriental art. The manifestos and criticism of the time seem to look for some point where all these factors would tangle and fuse.

The painter who outstandingly embodied these hopes was Paul Gauguin (1848–1903). Paul Sérusier (1864–1927), the student set in charge of Bonnard's class at the Académie Julian (to which teachers mostly descended on flying visits from the respectability of the École des Beaux-Arts), had shyly approached Gauguin in 1888 on a visit to Brittany, where the celebrated figure was working. He returned with a small panel painted under the master's instructions, which he vouchsafed to Bonnard and three other friends: Maurice Denis (1870–1943), Henri Ibels (1867–1936) and Paul Ranson (1862–1909). It came to be dubbed 'the Talisman' and its initiates the *Nabiim* or the 'Nabis', after the Hebrew for 'prophets'.

Whether or not this exalted title suited a shy, shortsighted law graduate of 21, Bonnard had little taste for the professional career in the law that was intended by his father. 'I think that what attracted me [to painting]', he said later, 'was less art itself than the artistic life, with all that I thought it meant in terms of free expression of imagination and freedom to live as one pleased.' He was obliged to train as a civil servant in the Paris Registry Office from 1888, but was accepted to study concurrently at the École des Beaux-Arts. The most evident results of his time at the latter institution, with its studies from the antique and its annual competition for the prestigious Prix de Rome, were the lasting friendships he struck up with Ker-Xavier Roussel (1867–1944) and, in particular, with Édouard Vuillard (1868–1940). Both were initiated into the Nabis. Bonnard's *Triumph of Mordecai* failed to win the Prix de Rome at the same time as he failed his civil service examination. However, he managed to redeem himself in his father's eyes by an artistic success in quite a different sphere. In 1889 he won a competition to design a poster advertising champagne, receiving the prize of 100 francs.

France-Champagne (Fig. 2), which in effect made Bonnard's artistic début when it belatedly appeared on the streets of Paris in 1891, may look less than innovatory after a century of familiarity with fin-de-siècle posters such as those of Henri de Toulouse-Lautrec (1864–1901). In fact it preceded them. Toulouse-Lautrec was one of many people struck by its brashly swaying lines and smooth swathes of colour, novelties of design learned from the paintings of Gauguin. He sought out the younger artist, was introduced to his printer and went on to take up a form that Bonnard later largely disregarded. But Bonnard's initial venture into the poster format was indicative of the outlook of the Nabis as a group. Their artistic ambitions were transferred from the type of set-piece talking-point easel painting, such as the Prix de Rome, that had been the focus of Paris's artistic attention for 200 years towards applied art of every sort. Sérusier and Denis, the theorists of

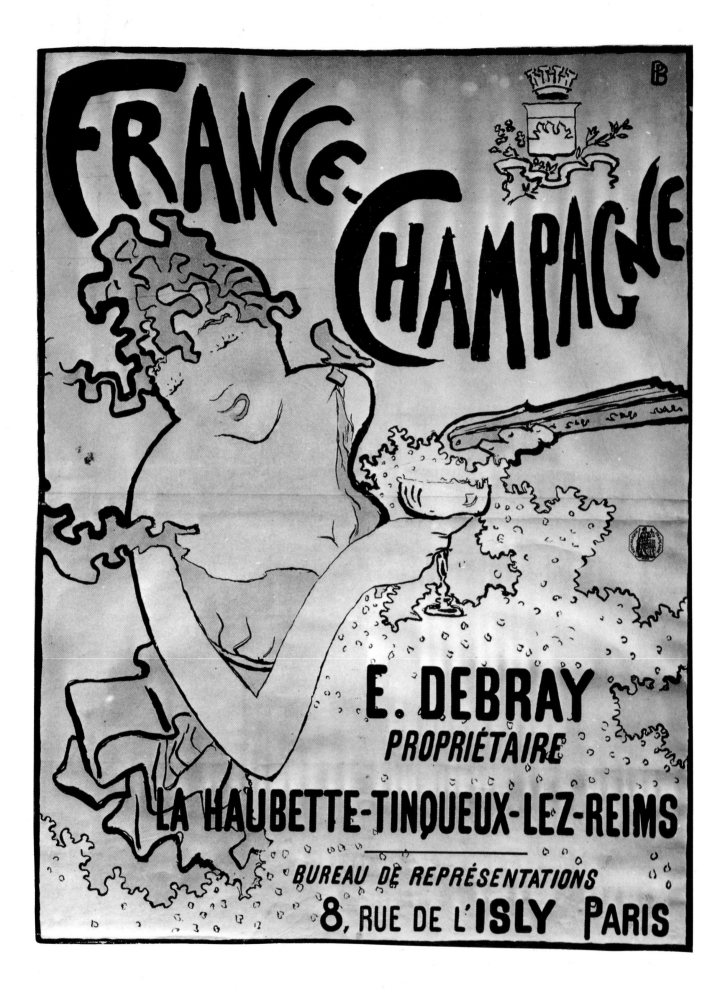

the group, interpreted Gauguin's example as showing that the artist's work should justify itself not through its subject matter but through 'the ability of its lines and colours to explain themselves'. Lines and colours would perform this function all the better if they stepped outside the framed illusion of the easel painting to enhance the whole environment in which people lived. Bonnard later spoke of his generation as always looking for 'the connections between art and life. At that time, I myself had the idea of a popular production with everyday application: prints, furniture, fans, screens, etc.' The poster's dream of seductive inebriety was a sort of first step along these lines.

The 100 franc fee convinced Bonnard *père* that his son's ambitions were realistic, and Bonnard rented his first studio after surmounting a last hurdle of social dues with a six-month stint of military service. He exhibited paintings at the Salon des Indépendants, the leading forum for innovatory work, from 1891 and with the dealer Le Barc de Boutteville from 1892. This early work shows Bonnard taking wholeheartedly to a culture that seemed to epitomize Nabi ideals: Japan. Besides avowed imitations like *The Peignoir* (Plate 3), it includes little observations from family or street life – his sister and cousin playing with dogs at Le Grand-Lemps, a soldier walking obliviously past a pretty girl – where the forms have been flattened and simplified and a repertoire of checkers and sinuous swirls helps translate the image from the 'illusion' the Nabis deplored to the 'decoration' they desired. The vision of '*le Nabi très japonard*' fell in with the work of Japanese printmakers such as Utamaro (see Fig. 3) in another way. The kind of allusive wit that led them to displace faces and figures from the centre of the picture, to make cropped appearances behind screens or at its periphery, was paralleled in Bonnard's sketches. His observations – often made on his own account from memory after walking in the streets – preferred to come between the human figures, obliquely, rather than to represent them four-square and fully in the traditional approach of Western artists. This habit became second nature to the shy observer and lasted throughout his career.

While other artists associated with Symbolist ideas, such as Odilon Redon (1840–1916), were exploring fantastical or mythical subject matter, Bonnard, like his friend Vuillard, was ostensibly keeping to the quotidian in his observations. The way in which his art subscribed to the 'Idea' was in that very obliquity of gaze seeming to pass beyond the apparent subject or figure to catch at the artist's subjective quality of perception. From about 1892 Bonnard began to develop a manner of drawing and painting that matched the open-ended character of his vision. His previously firm lines tended to break up into a flurried scatter of scribbles, in the interstices of which the subject lurked, as it were, by suggestion, rather than appearing stated and defined (Fig. 4). The resulting picture was therefore less what its title proclaimed – *Boulevard des Batignolles, The Circus* – than a record of the artist's sensitive activity, at a conscious remove from the fact. The new manner, with its deliberately gauche unlearning of academic draughtsmanship, may have had something to do with the thinking of Sérusier, who exalted the awkward and childlike as more trustworthy than the academic virtuoso. But in a sense the new hesitancy denotes a new boldness. Bonnard felt the freedom to experiment with an unprecedentedly loose manner because he was already recognized, at the age of 25, as an artist of note. Leading critics, such as Félix Fénéon, had singled him out for mention in a group of artists seen as being in the vanguard of contemporary art. From 1891 Bonnard was sharing a studio with Vuillard and Denis, and regularly meeting his co-exhibiting Nabis at Ranson's house, 'the Temple'. High-minded but lively, the Nabis

Opposite Fig. 2
France-Champagne
1891. Lithograph in
3 colours

Fig. 3
Utamaro, Baby
peering through its
mother's kimono
c.1804. Print

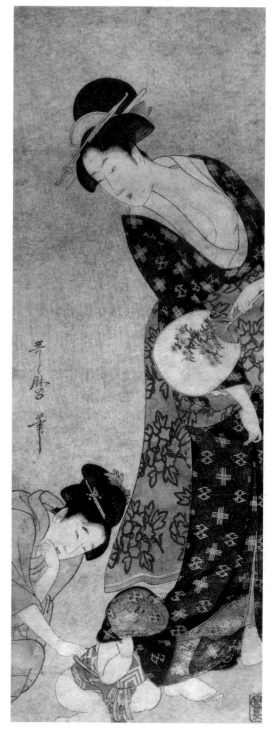

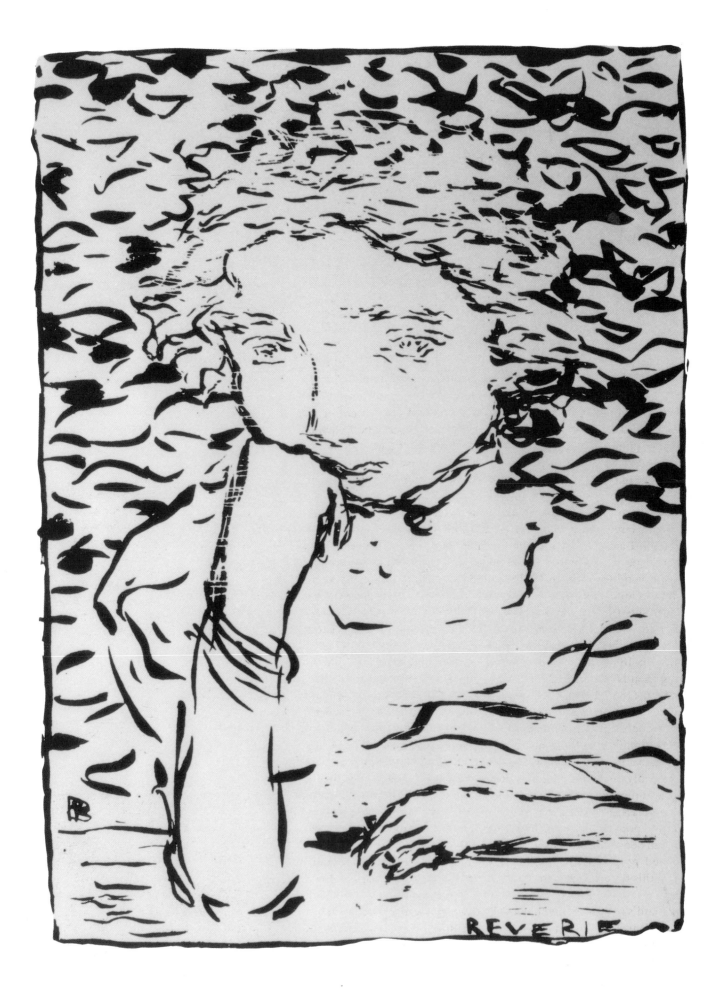

'were united by a camaraderie based on mutual esteem', according to Francis Jourdain, a frequent visitor. Other memoirs describe Bonnard as a quiet humorist within the group, contributing little when Sérusier or Denis launched into erudite intellectualizations, despite his own knowledge of philosophy from *lycée* days, but occasionally teasing them with deflating quips.

How much Bonnard cared about his place within the gradually expanding circle is questionable; interviewed in 1891, he said 'I am of no school, I am only seeking to do something personal'. But he was clearly working in a highly sympathetic context, offering connections to arts beyond painting; in 1892 he joined Vuillard in producing marionettes for innovatory productions at the Théâtre de l'Art, also working on stage sets for Ibsen and Strindberg. In 1893 he illustrated a music primer for children, *Le Petit Solfège* (Fig. 6). Its writer was Claude Terrasse (1867–1923), a musician who had married Bonnard's sister Andrée in 1890 and who became one of his closest friends. Other lasting friendships made during this expansive time included Thadée Natanson (1867–1951), the editor of *La Revue blanche*, who was to become one of his staunchest critical champions, and Natanson's wife Misia Godebska; both became important patrons. But the meeting of greatest significance for Bonnard's life and art took place in 1893. He fell in with a 16-year-old girl who gave her name as Marthe de Méligny. He probably encountered her as one of the pretty passers-by he liked to draw in his area of Paris around the place de Clichy – many of them working-class girls trying to raise their social status through sharp dress sense and pricy demeanour. The aristocratic '*de*' was part of this act: his lover had been christened Maria Boursin, although Bonnard apparently remained ignorant of this name until they married 32 years later. During this time a large part of his art was to revolve around her presence.

Bonnard's paintwork in the mid-1890s evolved step-by-step with his draughtsmanship, becoming darker, more suggestive, more ambiguous: earth-coloured grounds would do much of the work of the painting, ruffled here and there by greys and blacks, occasionally glanced by highlights. Much of his street imagery at this time was being transferred to lithography. He was keeping busy in all directions: besides

Opposite Fig. 4
Rêverie
1893. Lithograph in black

Top Fig. 5
The Painter's Life,
showing Ker-Xavier Roussel, Édouard Vuillard and Pierre Bonnard walking in the place de Clichy, and Toulouse-Lautrec, his cousin and Maurice Denis walking past the Moulin Rouge
c.1910. Pen sketch

Fig. 6
Major scale
from *Le Petit Solfège*
1893

SOLEIL DE PRINTEMPS

Le soleil du printemps luit — même pour les bourgeois — même pour les curés. — La noirceur du curé fait

valoir la candeur du soleil. — Des races ennemies dorment côte à côte. — Des races amies se manifestent leur

intérêt. — Des humains s'en inspirent. — Les races amies se redoublent les manifestations de leur intérêt.

— C'est, alors, qu'intervient le Repopulateur. — Le Satyre, dont les feuilles parisiennes ont annoncé la présence, sort

de sa maison. — Il entre dans une autre. — Il entre sans frapper. — Il est frappé. — Le Satyre, après. — D'autres Satyres.

Pierre BONNARD et Alfred JARRY.

various design commissions he worked on the 1896 stage production of *Ubu roi* by Alfred Jarry (1873–1907), whose sense of the ribald he was to share through several collaborations in the following years (see Fig. 7). This favoured career did not meet with universal approval. Camille Pissarro, writing to his son Lucien, described Bonnard's first one-man show in 1896 as deplorable, a 'fiasco', and declared the Impressionist generation – Monet, Degas, Renoir – to be in agreement with him. All however were to revise their views. Illustrations by Bonnard to a Danish novel, *Marie* (1897) by Peter Nansen (Fig. 8), moved Renoir to send a brief note of appreciation, '...absolutely exquisite... Hold on to this art.'

In Bonnard's recollection later in life of these words, they had been supplemented: '"You will encounter better painters than yourself, but yours is a precious gift." That, roughly, was what Renoir wrote...' The added self-appraisal perhaps implies a judgement that at the age of 30, for all his vivacity, Bonnard had yet to create anything of very great stature. The Nabis as a group had set out with loosely defined cultural ambitions – insofar as Sérusier's utopianism stretched to the mildly democratic Bonnard – but this agenda had mainly served as a pretext for exploring a range of art forms, and was gradually being dissipated as the members' individual careers diverged. Moreover the stock of images that linger from Bonnard's early work is lightweight, knowingly

Opposite Fig. 7
Soleil de printemps
1903. Ink drawing

Fig. 8
Illustration to *Marie*,
a novel by
Peter Nansen
1894

Et ces dames — scrutez l'armorial de France —
S'efforçaient d'entamer l'orgueil de mon désir,
Et n'en revenaient pas de mon indifférence.

Vouziers (Ardennes), 13 avril — 13 mai 1885.

LA DERNIÈRE FÊTE GALANTE.

Pour une bonne fois séparons-nous,
Très chers messieurs & si belles mesdames,
Assez comme cela d'épithalames,
Et puis là, nos plaisirs furent trop doux.

Nul remords, nul regret vrai, nul désastre!
C'est effrayant ce que nous nous sentons
D'affinités avecque les moutons
Enrubannés du pire poëtastre.

BALLADE DE LA MAUVAISE RÉPUTATION.

Il eut des temps quelques argents
Et régala ses camarades
D'un sexe ou deux, intelligents
Ou charmants, ou bien les deux grades,
Si que dans les esprits malades
Sa bonne réputation
Subit que de dégringolades!
Lucullus? Non. Trimalcion.

Sous ses lambris c'étaient des chants
Et des paroles point trop fades.
Eros & Bacchos indulgents
Présidaient à ces sérénades

14

charming. His witty sensibility, with its sly glance into the otherwise unheeded spaces and relations between passing figures, seemed most comfortable when confined to innocent-seeming, unmenacing subjects – animals, children and, for Bonnard's purposes, women. Although he hovered as an observer at the Moulin Rouge and other hubs of fin-de-siècle gaiety, his work never comes across as plunging in with the abandon of his friend Toulouse-Lautrec.

The canvases that Bonnard painted at the end of the century show a wish to go beyond these limitations – not by veering away from the basis of quotidian experience that always remained his mainstay, but by exploring it more deeply. The focus at this time on indoor experience, on the charged darkness of interiors, closely paralleled in the work of Vuillard, gave rise to the label 'intimisme', a term that has lasted although there is nothing programmatic about either artist's work. Bonnard's paintings of the period are, rather, intensely personal. The so-called 'Indolence' of 1899 (Plate 6) and the Man and Woman of 1900 (Plate 9) are powerful but quizzical images of sexual experience, boldly giving public shape to the interior space of his relationship with Marthe. The paintwork has a new fullness, re-engaging with volume and depth although in a hesitant, nervous fashion. These erotic works prompted the dealer Ambroise Vollard to commission Bonnard to illustrate Parallèlement, a volume of verse by the recently dead Paul Verlaine. Responding to Verlaine's sardonic, lubricious lyrics brought out from Bonnard an extraordinarily engaged performance as an illustrator, stretching him to produce fantasies of lesbian love-making, low-life debauchery and Rococo elegance, his rose-coloured lithographs blending with the text to make a bold imaginative continuity (Fig. 9). In these, as in another erotic painting, Siesta (Plate 7), Bonnard was starting to refer back to earlier European art. With this awareness of the past came a new weight of self-consciousness. The Terrasse Family (Plate 10) brings together the kind of incidental observations that Bonnard had always made at Le Grand-Lemps into one representative image – a personal version of the kind of Salon piece the Nabis had always shied away from.

These paintings came at a hinge in Bonnard's generally smooth career. From 1900 he started increasingly to absent himself from Paris, not only to spend the autumn in the Dauphiné but also to pass the spring with Marthe in rented cottages in the Seine valley between Paris and Normandy. The resulting landscapes that he painted coincide with a new interest in the work of the Impressionists. His predecessors had come on Bonnard in reverse order: having been raised artistically on Gauguin, he now regarded Impressionism as bringing 'a sensation of discovery and freedom', and began working up complex impastos to convey the shifting lights of northern France, while retaining his customary dun ground as a point of departure. In this concessionary period of his art, Bonnard also addressed himself rather tentatively to portraiture, his habitual resort to the quick private sketch and to memory sometimes resulting in a muzzy lack of presence. Transactions with the classical past continued in Daphnis et Chloé, the livre de luxe that Vollard commissioned to follow Parallèlement. Here the romance of Longus, a third-century Greek, spurred Bonnard to create, 'in a sort of happy intoxication' as he put it, some of his most lyrical, sharply drawn and inventive designs (Fig. 10). The Rococo of Watteau and Boucher, another past era on which period taste liked to linger, appears reflected in the small sculptures he attempted around 1906 and in his work at this time for Misia Godebska (Plate 12).

From 1906 Bonnard began to have annual one-man exhibitions with Bernheim-Jeune, dealers who showed a roster of many of the leading

Fig. 9
Illustrations to
Parallèlement, poems
by Paul Verlaine
1900

Fig. 10
Illustration from
Daphnis et Chloé
1902. Lithograph in black

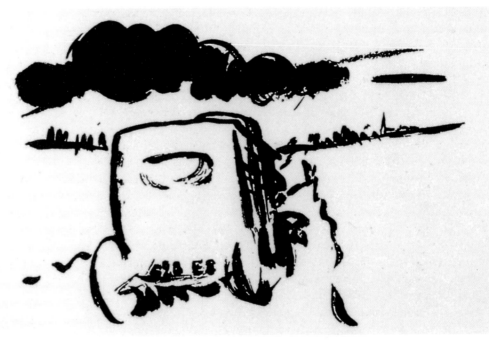

Fig. 11
Illustration from
La 628-E8 by
Octave Mirbeau
1908

Impressionist and Post-Impressionist painters and who were to to be the chief source of his income for the rest of his life. While his graphic commissions dwindled, portraiture and decorative projects helped his funds and the annual exhibition of about 30 canvases showed Bonnard as a reliable producer in genres the market was accustomed to – landscapes, interiors, portraits, still lifes, nudes. At the same time he had fallen entirely out of step with new artistic developments in Paris. Fauve painting such as that of Henri Matisse (1869–1954) and André Derain (1880–1954) had only the most glancing effect on him, and the advent around 1908 of Cubism, with its demand for intellectual rigour and its concern for structure, seemed quite antithetical to his avowedly personal, tentative mulling on impressions. A contemporary critic described his work as 'invertebrate', Picasso was later to call it 'a pot-pourri of indecision'.

Bonnard was not, however, of a nature to be ruffled into instant responses to outside pressures. Zealous in his privacy, he ensured himself such conditions as allowed him to work steadily and undistract-edly. This, while he and Marthe lived thriftily, involved much time for leisure and reflection. A contemporary impression by Natanson evokes a 'slim, active man' who 'seems tall although he stoops a little and folds up on himself, as if even his carriage means to be thoughtful', who 'detests above all to let himself be tied down by anyone, to be attached or enclosed anywhere...he goes on his way with long resolute strides, following nothing but the curiosity of his wayward spirit and his imagination to which he gives free rein.' Walking, cycling, sailing and motoring were all important to his way of life (his illustrations for Octave Mirbeau's *La 628–E8* in 1908 give an exuberant impression of early automobile tourism; see Fig. 11). During the years before the First World War he went on various tours in Europe and North Africa, but only a visit to Germany in 1913 left evidence in his work. It was mainly while moving around France – partly in a search for suitable conditions for Marthe's delicate health – that he felt comfortable to develop new pictures. These incorporated his broadening artistic knowledge, absorbed according to his own rhythms of working. The *Nude against Daylight* (Plate 13) of 1908 sums up his transactions with Impressionism, with the power of painted light to expand and animate a space, while achieving an entirely distinct mastery.

But despite the commanding nudes of this period and his regular presence at the Galerie Bernheim-Jeune, a sense of artistic inadequacy, indirectly brought on by Cubism, came to nag at Bonnard in his early forties. The monograph on his work that his nephew Charles Terrasse published, with his collaboration, in 1927 speaks of the ensuing period of his life as 'the years of anguish'. The path he had been following in his work towards accommodating the naturalistic light of Impressionism appeared to him, around 1912, as a dead end. He reproached Impressionism with a failure to attend to form, both in the structures of the natural world and in the making of the picture, for 'Art is not nature' nor should it be. His solution, he determined, would be to draw. 'And after drawing comes composition, which should have a balance. A well composed painting is half done.' These remarks to Terrasse rationalize an unease that showed in Bonnard's art throughout his forties. It finds expression in framing devices that as it were worry about the whole business of picture-making: the *Reflection in the Mirror* (Plate 18) for instance, or the windows that transform the world beyond into a 'view', a given picture. Frameworks indeed became Bonnard's chief remedy for his problems: the *Dining-room in the Country* of 1913 (Plate 22), by Terrasse's account the first major painting to benefit from the re-educative process, uses a firm, capacious structure to incorporate

Fig. 12
Illustration to
Correspondances,
memoirs by
Pierre Bonnard
1944. Pen sketch

a width of elements from life at Ma Roulotte, the cottage Bonnard had bought in the Seine valley.

The self-conscious mode persisted during the following years, through mirrors, windowframes, scenes within scenes; sometimes Bonnard was pitting his drawing against that of Degas, the greatest exponent among his predecessors of draughtsmanship as against Impressionist colour. If he seemed to be talking to himself, this was perhaps natural in a figure left on the sidelines of history. He exhibited little during the First World War: he did visit the Somme (Fig. 12) and paint the odd bombed village, but generally the twentieth century as an era of great and terrible events, of urgent political consciousness and insistent modernism, was something that bypassed him. Escapist, for a work so deeply rooted in personal experience, would be a wrong epithet: conformist, for a painter observing and indeed playing up to the given social conventions without demur, would be fair. He continued to execute decorative commissions for wealthy patrons, such as the

four panels painted for the Bernheim-Jeune family between 1916 and 1920 (Plate 23). With their setting out of that stock of personal experience into an orderly array, these panels are highly pitched, artful musings of a master considering his own created world. Without self-promoting effort, Bonnard was becoming a senior figure. In 1918 he was made the honorary president of a society of young French painters. The monographs were starting to appear.

And yet before him lay the decades that were to see his greatest work. Several memoirs remark on a persisting youthfulness in Bonnard that belied his years. It stemmed partly from his capacity to remain unsure, to reflect, to wander. During the years after the First World War Bonnard was regularly on the move – sometimes staying at Ma Roulotte in the north, sometimes at his Paris studio, but increasingly drawn to the Côte d'Azur, around Saint-Tropez and Antibes, an area he had first encountered in 1910. While Marthe's increasingly neurotic requirements may have motivated much of this scene-changing, he was also involved at this period with another model, Renée Monchaty (Plate 28). She killed herself in 1923, a dark that lies somewhere indefinitely behind the pictures' seeming dazzle. The occasional self-portraits speak of anything but composure. The fluctuation was given some ostensible resolution in 1925, the year that Bonnard decided to buy a house at Le Cannet, overlooking the Côte d'Azur, and finally married Marthe.

Their love is commemorated on the scores of canvases he had painted of her since 1893, in which her body, the image of his passion, remains unchanged by age. It was not, however, love on an equal footing. Natanson, who describes Marthe as having the 'wild look of a bird', evokes her 'anxious voice uttering quietly, quite tenderly "Pierre!"' and his 'replying brusquely, but paternally "Marthe!"'. Cut off from her roots, childless, implicitly patronized by much of Pierre's haut-bourgeois society, prey to his occasional unfaithfulnesses, she was isolated and as time went on increasingly paranoid. The world she made for herself was spare and inward-looking, revolving obsessionally around cleanliness – the first luxury installed at Ma Roulotte was a modern bathroom. As the Bonnards settled at Le Cannet she turned away Pierre's friends, fearing they were 'out to steal his secrets'; he would arrange to meet them by coming down to the café clutching his dog under his arm for an alibi.

But by her presence, by her needs, Marthe was in fact creating the conditions that made possible the extraordinary meditative masterpieces of the 1920s and 1930s. They are paintings that fit poorly into art history, having nothing to do with the plethora of 'isms' then making their way through painting in Paris. They are most comparable with the work of Bonnard's near-contemporary Matisse, with whom he struck up a neighbourly friendship on the Côte d'Azur – two senior figures setting themselves challenges on terms laid down several artistic generations before. External factors became more and more tangential to the work. The subject of retrospectives, his work was gathering an international reputation, leading Bonnard to visit the USA in 1926. He responded to the odd graphic commission from old friends like Vollard and Mirbeau, and in 1937 was honoured with the responsibility for decorating a pavilion at the Exposition Internationale in Paris – an opportunity which, by his own account, he fluffed: 'The only chance I have ever had to work on a large surface, and I failed to make good use of it, as usual.' The self-deprecation was unforced, but should be measured against his sense of vocation. 'I am working hard, buried deeper and deeper in that old-fashioned passion for painting. Perhaps I am, with a few others, one of its last survivors. The main thing is that I am not

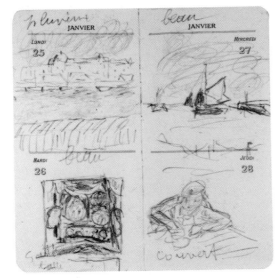

Fig. 13
Sketches by
Bonnard in his diary
1937

bored', he had written four years earlier.

The paintings from this period are often difficult to date, partly through lack of external factors, partly because of the way that Bonnard worked. This process – which he developed early in his career and probably only departed from during the Impressionist dalliance of the 1900s – began with what he called 'the idea' or 'the seduction'. During his daily walks, or at home or meeting people, something would as he put it 'seduce' him. It might be a direct observation, it might be the memory of one; he might jot it down there and then on a sheet of paper kept ready in his pocket, he might store it in his mind for future reference. (The American painter Harry Lachman remembered inviting Bonnard to join him to look for landscape views in Italy. Lachman turned up, set out easel, canvas, brushes, paints; Bonnard arrived and sat hands in pockets in his car. Asked where his equipment was, he replied '*Moi, j'observe*'.) The sketches in which Bonnard noted down his ideas – often, during the 1920s and 1930s, in diaries where they shared the page with a terse note of the daily weather (Fig. 13) – are entirely personal aide-mémoires. They have nothing of the demonstrative fine draughtsmanship common in artists working with one eye to the audience. This makes them all the more fascinating. Scribbling stutteringly with a stubby pencil, disregarding received ideas about representing volume or perspective, Bonnard was able to pack an extraordinary amount of information into every provisional, hurried mark (Fig. 14); the results ask to be read not instantly, as images that force themselves on you, but lingeringly, as maps of little discoveries about light, colour, movement, connectedness, all of which Bonnard is constantly improvising fresh ways to convey.

From these notations he would move on to canvas, sometimes scrawling the outlines of the picture he had in mind with charcoal – in his later years, generally onto the off-white of canvas primer, and on a generous scale, testing out the validity of the initial idea as far as it would extend. He liked to start his work 'on an unstretched canvas, larger in size than the surface chosen for painting; this means I can modify'. When motoring around France Bonnard would often pack a roll of primed canvas and pin it to the wall wherever he happened to stay; on it, works in hand might jostle with new ideas, their borders demarcated with strips of white paint. In this way he could continue his work anywhere, being undeflected from his purpose by the bad light and clashing wallpaper of hotel rooms. In his studio he would work on several canvases together: Angel Zarraga, a Mexican painter who watched him working at Antibes in the 1920s, reported that:

> when he begins a picture his composition is not
> immediately established...He simply walks back
> and forth between the white surfaces, waits for
> an idea, sets here a tone, there a brushstroke,
> puts several streaks on a third canvas. After a
> little while...he lays down his brush, calls his
> dog, who is always near...and goes for a walk with
> him on the beach. He chats for 15 minutes or a
> half hour with acquaintances he meets and then
> abruptly, but gently, he breaks off the conversation
> and returns quickly to his room. Seemingly at random,
> he sets down here and there, on one picture and
> another, a few accents which had meanwhile become
> clear to him and then goes out for another walk
> in order to relax and gather his energies for
> another attack.

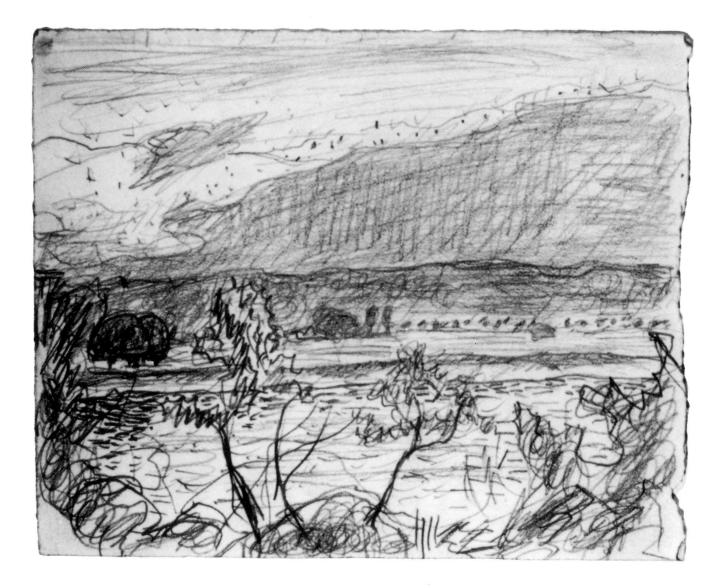

Fig. 14
The Seine near
Vernon
1920. Pencil sketch,
11.4 x 14.9 cm.
Mr and Mrs C. Fisher
collection

Other observers remember him singing or humming as he worked. He might sometimes return to his original motif to refresh his memory, but never for long. The toing and froing might go on over long periods: commissioned pictures could sometimes be held up for years until Bonnard had resolved to his own satisfaction some local difficulty. Other paintings however might be signed with the brushwork still raw, thin and hesitant, if he felt that it conveyed the seed of his idea. The process was potentially endless. Bonnard and Vuillard are reported to have visited museums where Bonnard's pictures were hanging: while Vuillard distracted the attendant, Bonnard would slip a small paintbox from his pocket and slyly amend some area that had come to nag him.

Using these methods in his maturity, Bonnard was working from a rationale learned in his youth. French thinking about art in the nineteenth century had turned around the concepts of 'Nature' – more or less, the observed world – of the academic tradition, of the ideal of beauty and of the artist's own vision. The Nabis' distinctive angle on this debate stemmed from their sympathy with Bergson's philosophy. This promised a freedom from the age's prevailing mechanistic ideas by setting against the measurable clock time of science the inner consciousness of time, 'duration'. In this, what I am doing now is inextricably fused with what I learned then and what I envisage will be; its reality is fluid and continuous. The nature of this element in which we most truly live can only be expressed by the artist, dwelling on particular images in the memory that seem intuitively to give focus to the

breadth of his experience. In literature, Bergson's cue was taken up by Proust; in art, the Nabis interpreted his ideas as meaning that Nature (what I see now) tradition (my experience of past art) and the beauty that I aim for could all focus and be fused in the artist's 'intuition'.

This intuition corresponds to Bonnard's 'seduction', the image around which his memory revolved. Its slow development took place in the kind of 'duration' Bergson described: the resulting pictures ask to be apprehended in an equivalent expanse of inner consciousness. The logic of the late work often relates less to the solid structures and distances of the world – the third dimension of depth – than to the long mental processes that give shape to experience over time. The way that a fanatically charged violet has come to lurk in the mouldings of a windowframe is the way that something formerly thought impossible has come to impress itself on us as inevitable; the way that the jugs on a table in a lower corner have developed strange internal harmonies all of their own is the way that we come to learn the language of a country which was once no more than a name. Features, background figures often only come into focus for the viewer after long familiarity. For all these reasons Bonnard's pictures are *par excellence* commodities for the private patron, intended to hang in particular rooms as the objects of repeated contemplation. The democracy of the public collection was for his purposes a second best: 'The museums are full of uprooted paintings', he said.

The working method has its limitations. For all the prodigious resources of his memory of past art, for all his power to nurture a full-grown canvas from a tiny seed pencilled from nature, Bonnard can sometimes make large demands on the viewer's sympathy when he tries to shore up with accretions of paint a perception that was from the outset vague, a figure that can at most be read as an intention. Bonnard acknowledged this fallibility, but was not to be deflected from his chosen path. He said that someone had once pointed out that he had given a nude two right feet, but that he had left it. 'After all, somehow, it seems to me better like that. It makes an interesting shape.' Whatever was worthwhile in the picture stemmed from its original idea. Too much contact with the motif subsequently would drag him down into the detail, the retailing of measurable facts that his art had from its Nabi beginnings run counter to. 'I am very weak', he explained, 'it is difficult for me to keep myself under control in the presence of the object': he had to work away from it. Only someone like Titian – the artist he most revered – could hold the original vision persistently while working before any subject directly; lesser painters, he said, fell into mere copying of objects when they moved outside a certain zone of interest. Cézanne, Monet and Renoir achieved their successes by choosing subjects carefully to suit their abilities. In the same way, so Bonnard's reasoning went, he was restricting himself to subjects in which he could realize his own ideals of beauty.

On one level, what this area consists of is perfectly obvious. Bonnard was 'seduced' by the presence of things that he knew well and cared about – women, children, dogs, cats, laid tables, flowers, fruit, the Seine valley, the place de Clichy, the Côte d'Azur. His painting witnesses the distinct life of all these entities, and those who knew him could often recognize minutiae of his world as identifiable within it. But it is equally obvious that the pictures are not painted primarily for the sake of recording that world – given the oblique, side-stepping nature of Bonnard's gaze, given his disdain for mere detail, given his insistence on 'the idea'. What they record is rather the quality of that gaze itself: the act of perceiving rather than the objects perceived.

The difference between the two is not hair-splitting. If I am con-

cerned with the objects themselves, my picture will naturally build up around them. But if I consider what my gaze takes in, it often includes large stretches of nothing in particular – a slowly receding wall, say – between the objects that are the natural foci of interest. Dwelling on those expanses brings the gaze itself into focus. Thus Bonnard paradoxically proposed 'To begin a picture there must be a void in the middle' and acts on this principle in different ways in pictures ranging from the *Reflection in the Mirror* (Plate 18) to *The Palm* (Plate 36), thrusting the incidents into the corners. There is also the consideration that straight lines in our shared space can, when plotted out in the field of my gaze, bow out as they recede from me. Bonnard obeys these curvatures in paintings like *The Dining-room Overlooking the Garden* (Plate 39), although he is equally concerned to relay what he knows even as he gazes; thus the crockery on the table is stretched downwards to give it its most characteristic aspect.

Thus, while Bonnard's motifs are anything but revolutionary, his presentation is deeply innovatory. A paradoxical rhetoric, comparable to that of the Greek philosophers he had studied, leads him to base pictures on reversals and upendings of expectation, to dare himself to experiment with ever more demanding visual conceits in his late work. With this comes an equally novel approach to colour, to the actual paintwork of the picture. The whole field of the picture-as-gaze must be thoroughly developed in every passage and corner: 'there must be no gaps'. This means holding back involving elements, such as faces and identities, which have a tendency to run away with the picture, and building up gradually – with brush and rag – a continuity of colour juxtapositions. Bonnard learned from the Impressionists to analyse observed colours and set down their constituents in adjacent brushstrokes, but his play of differences serves other ends. 'Colour', he commented with regard to their work, 'could be exploited much more as a means of expression'; accordingly, he tugs away at natural hues to make them yield their maximum expressive potential, extrapolating mauves and oranges never seen before in nature or in art. It is the aspect of his art that is least conciliatory, most visceral and daring.

Insofar as Bonnard explained the processes of his vision – partly through Charles Terrasse's book, partly through the 'Notes of a Painter' he jotted down in his diaries of the 1930s and 1940s – he justified them as a way of affirming the human, as against the camera's mechanicalness. 'The painter's eye...reproduces things as a human eye sees them. And this vision is *mobile*. And this vision is *variable*...' But the content of value Bonnard put into that laden word 'human' emerges if we remember that he initially wanted to paint for the sake of 'free expression of imagination and freedom to live as one pleased'. The great paintings that were the eventual result of this desire were his own meditative freedom from circumstance, from the drag of the mechanical that Bergson opposed, and he believed that in creating this space for himself he was creating it for others.

Yet his work at its most extended, a painting like the 1937 *Nude in the Bath* (Plate 42) with its imperious reconfiguration of nature, can seem less a shared meditation than a submersion of one woman's individuality in the interests of one man's singular vision. What had the frail, ageing, distracted Marthe to do with the fluctuating mirage devised by her harried husband? Bonnard's transmutations of the objects of his gaze – his admirers have often reached for the term 'magician' – can seem wilfully solipsistic. A true solipsist, however, would not make pictures for others to see; and Bonnard, always intent to learn, was under no illusion about the power of his art. 'When one distorts nature, it still remains underneath, unlike purely imaginative works.' His pictures

bear witness to the tension between the boundedness of one man's gaze and the vastness of the solid shared world, a tension implicit in the undertow of melancholy that follows on their keen initial delight.

A similar tension colours one of the few acts that seem to show Bonnard in a dishonourable light. Six months after Marthe's death in 1942, he forged her will. Their marriage certificate had given them joint possession of all property; this would mean that unknown relatives of hers might end up with half his paintings; why should he not make it out that she had signed them all over to him? Was he not, in fact, to all intents and purposes her sole voice? But, absurdly, as if knowing the gesture futile, he neither attempted to disguise his own handwriting, nor even bothered to backdate the document. (The legal wrangles when this was discovered after his death kept much of his work sequestered for 21 years.)

Bereaved in a defeated country, Bonnard continued to paint through the Second World War, held to his base of Le Cannet, working with a tremulous power that echoes the old age of his hero Titian. His work was beginning to fetch vast sums, a matter of no interest to him – 'All these zeros get on my nerves' – and younger painters came to him for advice. Never having had a master to work under, he had never seen himself in this role: when he took a stab at offering advice to students at an academy set up by Ranson, in 1909, he ended up saying 'I never know which one of us is right'. Now, however, he did venture to offer up to an interested magazine his 'Observations on Painting', culled from his notebooks. They are insights completely without didacticism, meditative little apophthegms about beauty, nature, line, colour and, above all, what served the interests of the picture: 'The main subject is the surface, which has its own laws, over and above those of the objects.' At this point Bonnard's presence starts to re-enter the mainstream of the art history he had side-stepped for four decades: such remarks, and the look of much of the late work, provided cues for abstract painters like Nicolas de Stael and, indirectly, for the American Abstract Expressionists.

Bonnard, however, as he had long ago said, was not of any school; he considered that, nearing his eightieth birthday, he was still trying to learn. The paintings of his last decade include works of a new emotionalism; a *St Francis* for a church in Savoy, a *Circus Horse* (Fig. 31) full of baleful pathos. The 1936 *Nude in the Bath* (Plate 42), with its dazzling fall of radiance, led the way into a vision less concerned with the particular forms of the observed world – which were often reduced to childlike ciphers – and more intent on the light that gave them their being – an immateriality given substance by the colour yellow. Paintings such as *Young Women in the Garden* (Plate 28), begun 20 years earlier, were reworked in an almost desperate attempt to draw further strength from this source of power. 'Our God is the sun', he told a young painter: implicitly, pigment stood in relation to its pure light as the human to the divine. Could paint ever sufficiently embody the truth of his seeing? Some months before his death in January 1947, he was writing: 'I am only beginning to understand. I should start all over again...'

Outline Biography

1867 Born at Fontenay-aux-Roses, near Paris, 3 October

1886 Begins to study law at the University of Paris

1887 Enrols at the Académie Julian: meets Paul Sérusier and Maurice Denis

1888 Takes law degree. Sérusier forms the artistic group the 'Nabis', including Bonnard and three fellow students

1889 Works at registry office; also studies at the École des Beaux-Arts, where he meets Édouard Vuillard. Wins competition to design *France-Champagne* poster

1890 Military service. Rents first studio

1891 Exhibits at the Salon des Indépendants, with other Nabis

1893 Illustrates *Le Petit Solfège*. Meets 'Marthe de Méligny' (Maria Boursin)

c.1894 Active in Nabi exhibitions and working for *La Revue blanche*

1896 First one-man show with Durand-Ruel

1898 Lithographs published in *Quelques Aspects de la vie de Paris*; works with the dramatist Alfred Jarry on stage-sets, puppets, illustrations

1900 Last exhibition of the Nabis as a group. Paints *Man and Woman*; illustrations to Verlaine's *Parallèlement* published. Starts to spend increasing amounts of time outside Paris, passing springs in the Seine valley

1902 Illustrations to *Daphnis et Chloé*

1905–13 Travels in the Netherlands, England, Spain, North Africa, Spain, Germany

1906 First one-man show with Bernheim-Jeune, with whom he henceforth exhibits regularly

1908 Paints *Nude against Daylight*; illustrates Octave Mirbeau's *La 628–E8*

1910 First encounters the Côte d'Azur, at Saint-Tropez

1912 Buys the house 'Ma Roulotte' at Vernonnet in Normandy

1913 Paints *Dining-room in the Country*

1916–20 Works on decorative panels for the Bernheim-Jeune family

1918 Made president of honour, with Renoir, of the '*Groupement de la Jeune Peinture française*'

1924 Major retrospective at the Galerie Drouet

1925 Marries 'Marthe' (Maria Boursin)

1926 Buys a house he names 'Le Bosquet' at Le Cannet on the Côte d'Azur; visits the USA. From now until 1939 based chiefly at Le Cannet, though also staying for periods at Arcachon and Deauville

1927 Publication of the monograph *Bonnard* writen by his nephew Charles Terrasse, with his assistance

1937 Designs decoration for the French pavilion at the Exposition Universelle, Palais de Chaillot

1939–45 War confines him to the Côte d'Azur

1942 Death of Marthe Bonnard

1944 Publication of *Correspondances*, reminiscences

1945 Revisits Paris

1947 Dies at Le Cannet, 23 January

Select Bibliography

C. Terrasse, *Bonnard*, Paris, 1927

T. Natanson, *Le Bonnard que je propose*,
 Paris, 1951

Bonnard and his Environment, exhibition
 catalogue, texts by J. T. Soby, J. Elliott
 and M. Wheeler, New York, 1964

J. and H. Dauberville, *Bonnard: Catalogue
 raisonné de l'oeuvre peint*, 4 vols, Paris,
 1965–74

A. Vaillant, *Bonnard*, London, 1965

A. Fermigier, *Bonnard*, London, 1970

P. Heron, *Bonnard the Draftsman*,
 New York, 1972

J. Clair, *Bonnard*, Paris, 1975

F. Bouvet, *Bonnard: L'Oeuvre gravé, catalogue
 complet*, New York, 1981

S.H. Newman, ed., *Bonnard*, exhibition
 catalogue, New York, 1984

Drawings by Bonnard, exhibition catalogue,
 texts by A. Terrasse and S. Mann,
 London, 1984

Hommage à Bonnard, exhibition catalogue,
 Bordeaux, 1986

Bonnard photographe, exhibition catalogue,
 Paris, 1987

M. Terrasse, *Bonnard at Le Cannet*,
 London, 1988

G. Josipovici, *Contre-jour*, Manchester, 1986

A. Terrasse, *Bonnard*, Paris, 1988

Pierre Bonnard: The Graphic Art, exhibition
 catalogue, texts by C. Ives, H. Giambruni
 and S. Newman, New York, 1989

N. Watkins, *Bonnard*, London, 1994

List of Illustrations

Colour Plates

1 Self-portrait
c.1889. Tempera on canvas, 21.5 x 15.8 cm.
Private collection

2 Two Poodles
c.1890. Oil on canvas, 36.3 x 39.7 cm.
Southampton City Art Gallery, Southampton

3 The Peignoir
c.1890. Oil on silk glued on canvas, 154 x 54 cm.
Musée d'Orsay, Paris

4 La Revue blanche
1894. Lithograph in four colours, 80 x 62 cm

5 Street Scene, Place Clichy
c.1895. Oil on cardboard, 35.3 x 27 cm.
Jacques and Natasha Gelman Collection,
Metropolitan Museum of Art, New York

6 'Indolence'
c.1899. Oil on canvas, 92 x 108 cm.
Josefowitz Collection

7 Siesta
c.1899. Oil on canvas, 109 x 132 cm.
Felton Bequest, National Gallery of Victoria,
Melbourne

8 Young Woman under the Lamp
c.1900. Oil on cardboard, 60.6 x 73.1 cm.
Musée des Beaux-Arts, Berne

9 Man and Woman
1900. Oil on canvas, 115 x 72 cm.
Musée d'Orsay, Paris

10 The Terrasse Family
1900. Oil on canvas, 139 x 212 cm.
Musée d'Orsay, Paris

11 Ambroise Vollard
c.1904-5. Oil on canvas, 74 x 92.5 cm.
Kunsthaus, Zurich

12 'Pleasure'
1906. Oil on canvas, 250 x 300 cm.
Galerie Maeght, Paris

13 Nude against Daylight
1908. Oil on canvas, 124.5 x 108 cm.
Musées Royaux des Beaux-arts de Belgique,
Brussels

14 Misia
1908. Oil on canvas, 145 x 114 cm.
Thyssen-Bornemisza Collection, Madrid

15 The Cherry Tart
1908. Oil on canvas, 115 x 123 cm.
Private collection

16 Early Spring
1908. Oil on canvas, 87.6 x 132.1 cm.
Phillips Collection, Washington, DC

17 The Little Fauns
1909. Oil on canvas, 103 x 126 cm.
Hermitage, St Petersburg

18 Reflection in the Mirror
1909. Oil on canvas, 73 x 84.5 cm.
Private collection

19 The Red-checkered Tablecloth
1910. Oil on canvas, 83 x 85 cm.
Private collection

20 Woman with Parrot
1910. Oil on canvas, 104 x 122 cm.
Private collection

21 The Place de Clichy
1912. Oil on canvas, 139 x 205 cm.
Musée des Beaux-Arts et d'Archéologie,
Besançon

22 Dining-room in the Country
1913. Oil on canvas, 168 x 204 cm.
Institute of Arts, Minneapolis, MN

23 Pastoral Symphony
1916-20. Oil on canvas, 130 x 160 cm.
Bernheim-Jeune, Paris

24 The Terrace
1918. Oil on canvas, 159.5 x 249.5 cm.
Phillips Collection, Washington, DC

Text Illustrations

Comparative Figures

16 Narrow Street in Paris
c.1897. Oil on wood, 40 x 21.5 cm.
Phillips Collection, Washington, DC

17 Édouard Vuillard, Two Women in
Lamplight
1892. Oil on canvas, 31.1 x 40 cm.
Musée de L'Annonciade, Saint-Tropez

18 Photograph of Pierre Bonnard
in the nude
1900-1901. Musée d'Orsay, Paris

19 Photograph of Marthe in the nude
1900-1901. Musée d'Orsay, Paris

20 Illustration to *Parallèlement*
1900. Lithograph in pink sanguine

21 Illustration of Chloe garlanding Daphnis
from *Daphnis et Chloé*
1902. Lithograph

22 Woman and Dog
1891. Oil on canvas, 30 x 32 cm.
Phillips Collection, Washington, DC

23 Movement of the Street
1901. Oil on canvas, 36 x 48.8 cm.
Phillips Collection, Washington, DC

24 Nude in Front of the Fireplace
1914. Oil on canvas, dimensions unknown.
Whereabouts unknown

25 The Terrace at Ma Roulotte
c.1928. Pencil, 27.5 x 30.5 cm.
Private collection

26 16 Piazza del Popolo
1921-3. Oil on canvas, 79.5 x 96.5 cm.
Phillips Collection, Washington, DC

27 Study of Nude
c.1924. Pencil., 24.8 x 32.8 cm.
Private collection

28 The Bath
1925. Lithograph in black, 33 x 22.5 cm

29 Standing Nude, with Head of Artist
1930. Charcoal, 60.3 x 45.7 cm.
Private collection

30 Bay at Saint-Tropez
c.1938. Oil on canvas, 41 x 68 cm.
Musée Toulouse-Lautrec, Albi

31 The Circus Horse
1936. Oil on canvas, 94 x 118 cm.
Private collection

32 Photographs of Pierre Bonnard and his
studio at Le Cannet
c.1945

1 Self-portrait

c.1889. Tempera on canvas, 21.5 x 15.8 cm. Private collection

'*Timide et myope*' was how Bonnard struck his friend Thadée Natanson on their first meeting, some four years after this self-portrait was painted. By that time Bonnard had evolved his characteristic method of working primarily from memory; but his earliest paintings are direct observations from nature, following the practice of nineteenth-century *plein air* painters such as Jean-Baptiste-Camille Corot. Some depict landscapes in the Dauphiné, the land on the east bank of the Rhône where the Bonnards had originated and where the family spent their vacations; others employ Bonnard's sister Andrée and cousin Berthe Schaedlin as subjects. Artists starting their careers, with slender resources and confidence to command, are often forced back on their own features, mirrors being cheaper than models; but there is nothing of the mere exercise about the introspection here. The palette and brush affirm Bonnard's choice of career – the high collar and tie were standard uniform for students at the Académie Julian, where he was studying part-time in conjunction with his law degree – but within this public persona he is intent upon his musing interior dialogue.

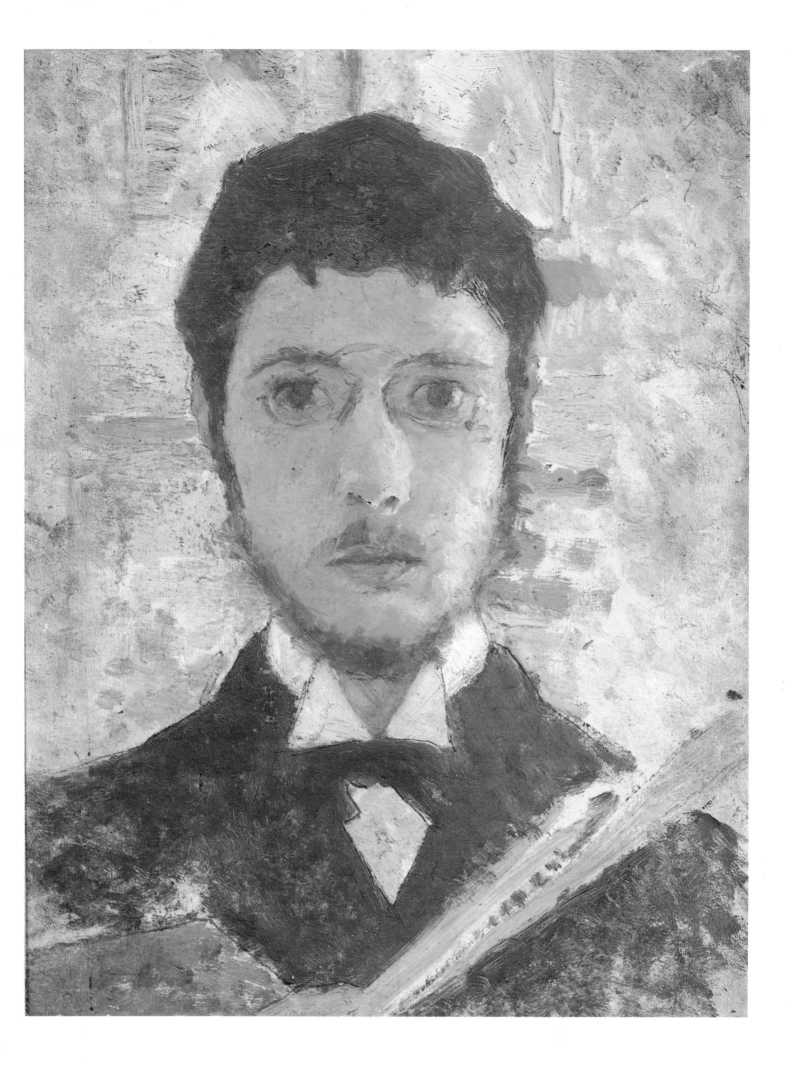

Two Poodles

c.1890. Oil on canvas, 36.3 x 39.7 cm. Southampton City Art Gallery, Southampton

Bonnard's early draughtsmanship is incisive and exact, proceeding with a sly wit and delight in familiar matters. The playful scrap here may well have been devised from two drawings of Bonnard's dog, Ravageau, combined. The concise, light-hearted subject lends itself readily to the stylistic precepts of the Nabis, the group Bonnard joined in autumn 1888. Sérusier, its initial leader, took from the paintings of Gauguin the idea of *cloisonnisme*, of separating areas of observed hue into 'cloisons' or compartments of strong undifferentiated colour. The idea was to get away from a mechanical academic imitation of nature, involving modelling and spatial depth, the better to concentrate on the expressive possibilities of line and colour as such. The danger of this procedure – that the resulting compartments can end up not so much pure as vacuous – is here circumvented by dwelling on the textures of the poodles' coats and the grass they play in.

The design was originally intended for a panel inserted in the door of a cabinet, a project Bonnard submitted unsuccessfully to a competition for furniture design.

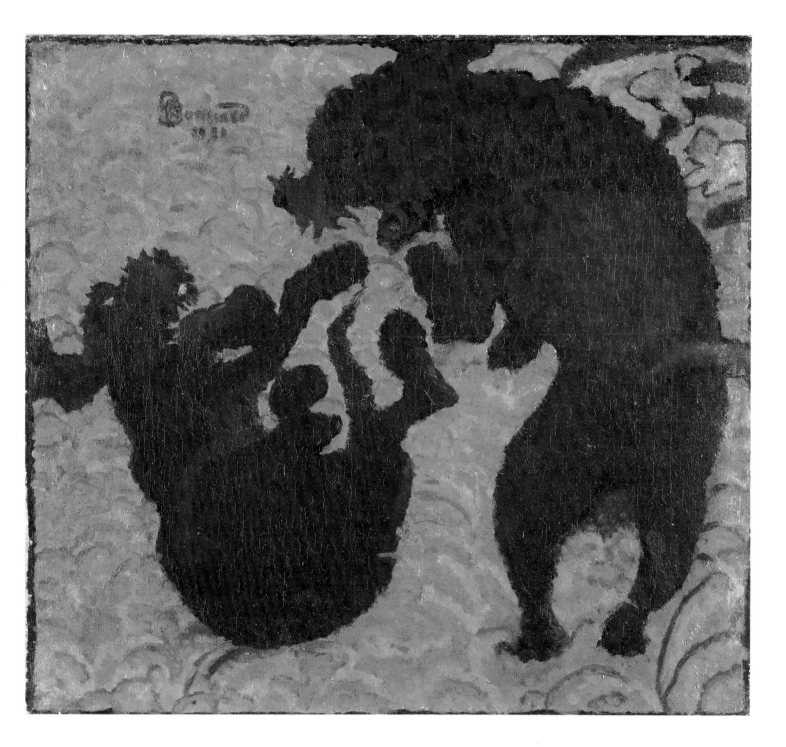

3 The Peignoir

c.1890. Oil on silk glued on canvas, 154 x 54 cm. Musée d'Orsay, Paris

A *peignoir* is a loose gown or robe such as a model might wear about the studio; but there is no need to assume any observation from the model behind this wholehearted homage to Japanese art. The pose is traditionally one of the courtesan, trailing an enticing glance over her retreating shoulder. But Bonnard seems to have latched on to the motif purely for its potential for weaving patterned marks around an oblique, minimal human presence. The work has been taken further away from the normal premises of Western art by the use of a tawny silk glued (*marouflé*) to the stretched canvas. On this ground, resembling the gold leaf used in Japanese screens, Bonnard has dabbed touches of colour in a manner rather similar to the early paintings of his friend Édouard Vuillard. The resultant richness has an almost abstract quality that only returned to Bonnard's art in his old age. His early exotic interests, which were spurred by a major show of Japanese prints at the École des Beaux-Arts in 1890 and which led to his friends calling him, following a review by Félix Fénéon, '*le Nabi très japonard*', were gradually reintegrated with more everyday imagery after 1892.

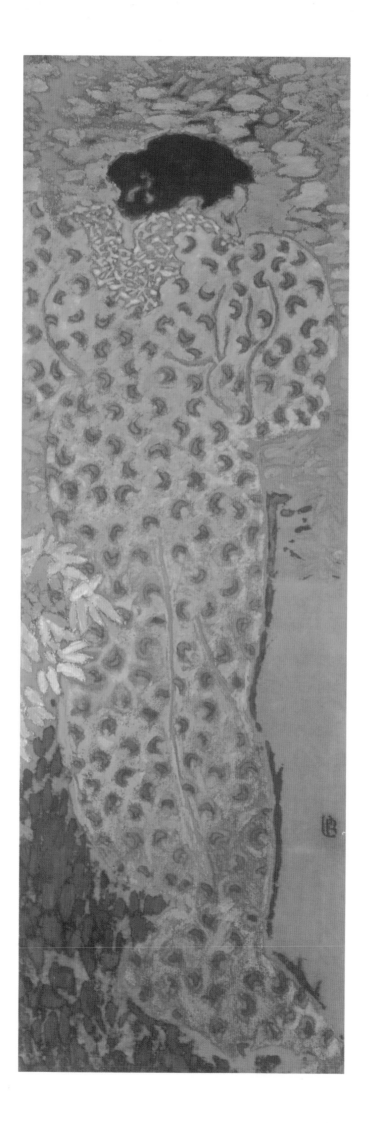

4 La Revue blanche

1894. Lithograph in four colours, 80 x 62 cm

The poster advertises the monthly magazine that set the style for the Parisian intelligentsia during the 1890s. *La Revue blanche* was started up in Paris in 1891 by Thadée, Alexandre and Alfred Natanson, brothers from an emigré Polish–Jewish banking family. Thadée was editor-in-chief, and the magazine spanned his interests in literature, art and politics. It published the later poems of Stéphane Mallarmé and the early writings of Marcel Proust and André Gide; art criticism by Natanson himself and by Félix Fénéon promoted the Nabis and other innovatory artists; in politics, while publishing opinions ranging from the conservative to the anarchist, it became committed to the exoneration of Captain Dreyfus, whose conviction for spying in 1896 led to profound and acrimonious divisions in French society for more than a decade. On this issue Bonnard, who was one of the chief contributors of graphic material to the review, seemingly maintained a studious neutrality, retaining friends on all sides.

The poster's sense of Parisian chic is achieved through a daringly cool, sombre choice of colours. The process of lithography, Bonnard later claimed, helped his painting: 'When one has to establish relations between tones by ringing the changes on only four or five colours, juxtaposed or superimposed, one makes a host of discoveries.' The drawing is characteristic of Bonnard's work of the mid-1890s in leaving as much as possible to suggestion – demanding several blinks, when viewed at close range, before one recognizes the top-hatted gentleman inspecting magazines behind the hollering newsboy.

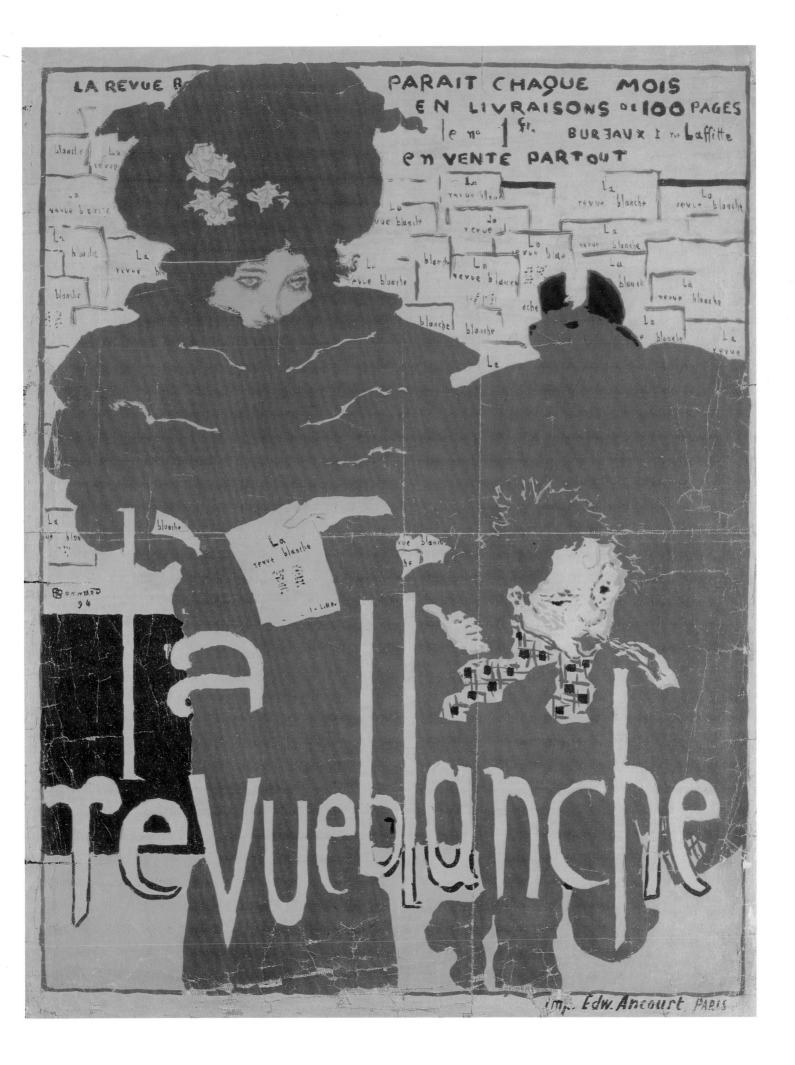

c.1895. Oil on cardboard, 35.3 x 27 cm. Jacques and Natasha Gelman Collection, Metropolitan Musem of Art, New York

Fig.16
Narrow Street in Paris
c.1897. Oil on wood,
40 x 21.5 cm.
Phillips Collection,
Washington, DC

The place Clichy, at the lower end of Montmartre, was the heart of the Paris Bonnard knew. From 1890, he rented studios in nearby streets, in company with Vuillard and the actor Lugné-Poe; eastwards along the boulevard de Clichy stood the Moulin Rouge celebrated by his friend Toulouse-Lautrec. The confluence of streets, with its lively, scruffy mix of working-class streetlife, small businesses, bars, tramps, whores, artists and every sort of bohemian, became the base for hundreds of sketches, lithographs and paintings, seizing on the scene's most evanescent aspects. Bonnard's sensitivity to the modish wealthy young lady, with her lacy ruff and her poodle, terrier and whippet, caught against the costermonger's barrow and shopfronts, is typical: he is habitually the sly observer in this context, catching its social conjunctions unawares, probably working from a quick sketch made on the spot. A wish to maintain a personal distance is also discernible in his contemporary sparrow's-eye views of the same streets (Fig. 16). *Street Scene, Place Clichy* has been painted on cardboard, a ground used by other Nabis such as Vuillard and Félix Vallotton – partly in a break with the art-historical overtones of canvas. In the mid-1890s Bonnard's palette had settled into a dark, muted range which suited his impulses towards suggestion and indirection, painting what his nephew Charles Terrasse called 'a world seen through grey cottonwool'.

'Indolence'

c.1899. Oil on canvas, 92 x 108 cm. Josefowitz Collection

While Bonnard's working patterns involved returning repeatedly to the same subject matter, he rarely reworked a single motif over a succession of canvases. This image is an exception. It first appears in a small oil sketch; then in the version here; then in a second larger oil painting, bought by Thadée Natanson; the same pose also appears reversed in a further canvas and adapted for a lithograph in Bonnard's illustrations for Verlaine's *Parallèlement*. The title *'Indolence'* seems first to have been attached to the version owned by Natanson. It is of a piece with that version's added wisp of gauze and elegantly abandoned expression – attempts to package with tastefulness an erotic charge that the artist still wished to draw on. This earlier canvas makes it clear that the woman is not so much indolent as inviting. But its fascination lies principally in the singular tension of her body and in the way the spectator is implicated in a relation to it – her eyes look up to a male presence, high but close, while the returning gaze takes in beyond her the wide expanse of bed and the pipe, a further sign of that presence, on the table beyond. In this new spatial involvement, in its use of light and cast shadow and in its insistence on the truths of private experience, the painting broke new ground in Bonnard's development.

Siesta

c.1899. Oil on canvas, 109 x 132 cm. Felton Bequest, National Gallery of Victoria, Melbourne

Siesta offers a marked contrast to the other large erotic canvas of this period, *'Indolence'* (Plate 6). Where the latter's sexuality is angular and challenging, this post-coital image is sumptuously relaxed. The modulation of light across the room and the fuller figure is more naturalistic than anything previously attempted by Bonnard. (He keeps, however, to his decorative instincts in refusing to recede the stripes in the wallpaper.) The room, with its jolly harmonies of red and green, suggests a narrative context giving respectability to the eroticism – the girl's beribboned lapdog could come out of some novel or painting from the mid-eighteenth century, an era over which Parisian cultured nostalgia currently liked to linger.

The pose itself closely echoes the statue of the *Hermaphrodite* in the Louvre. This is one of the first instances in which Bonnard's art bears the memory of earlier Western art, although he would have been familiar with the classical works in the Louvre since his studies at the École des Beaux-Arts in 1889. Over the following decades frequent reminiscences of classical statuary would give the painting an added complexity of resonance, but here it seems purely a pretext for the decorous sexiness.

Young Woman under the Lamp

c.1900. Oil on cardboard, 60.6 x 73.1 in. Musée des Beaux-Arts, Berne

Working on a dun ground like cardboard allows the painter to evoke and create with great economy: this painting could have been done without any preparatory drawing on its surface, letting the scene form itself around the gold of the lamp. Two different things have been imagined on different planes – the warm feminine world of sewing that wanders downhill in the foreground, and the implicitly masculine world suggested in the viridian recesses of the interior.

The method and imagery are close to those of Bonnard's friend Édouard Vuillard, with whom he was in constant contact through the 1890s, and similar scenes were depicted by their Nabi colleague Félix Vallotton, albeit with a startling accent on alienation that contrasts with the tenderness displayed here. The vein of homely subject matter has led to the epithet '*intimisme*', a description that Bonnard himself intermittently used to describe his work. Bonnard and Vuillard remained devoted friends until the latter's death in 1940, although a reserve inherited from their encounter at the École des Beaux-Arts always precluded them from addressing one another as '*tu*'.

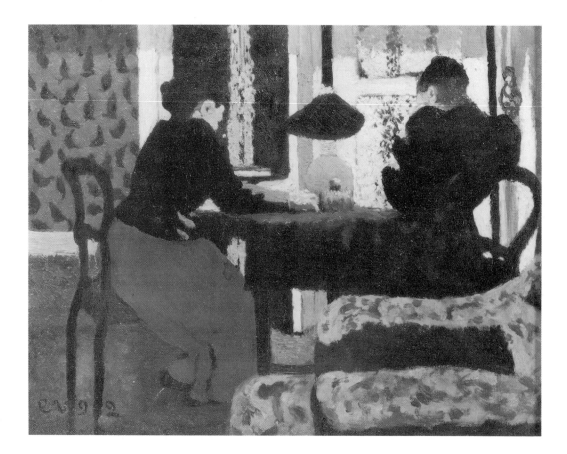

Fig. 17
Édouard Vuillard,
Two Women in
Lamplight
1892. Oil on canvas,
31.1 x 40 cm.
Musée de L'Annonciade,
Saint-Tropez

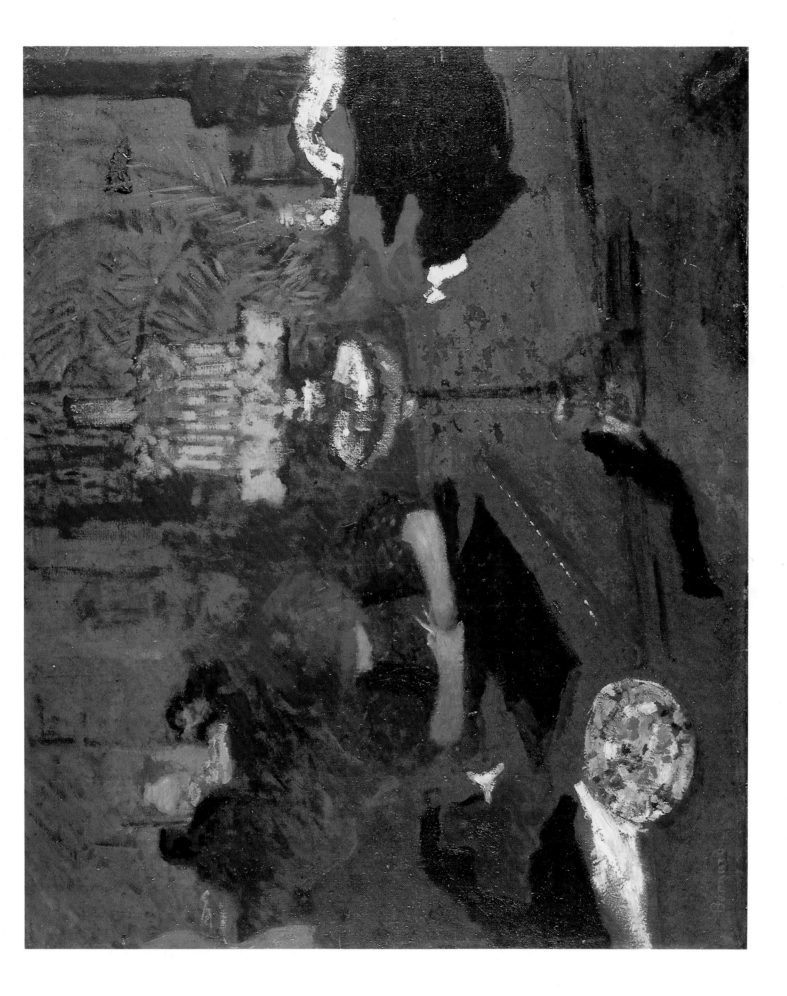

1900. Oil on canvas, 115 x 72 cm. Musée d'Orsay, Paris

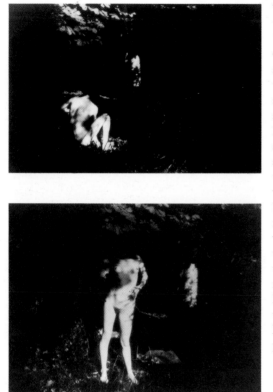

The central screen dividing the couple, and their brooding attitudes, mark the painting out as bearing a loaded weight of meaning unusual in Bonnard's early work; but that meaning remains characteristically oblique. Contemplation of the roles of the sexes, of the enduring destiny of 'Man' and of 'Woman' as such, was a common strand in late nineteenth-century thinking, given expression in writing by Nietzsche and August Strindberg and in painting by Edvard Munch, whose work had attracted much attention when exhibited in Paris in 1897. To some extent the imagery here, allotting the woman her in-turned, retreating world with accompanying kittens and showing the man stepping forward to question and confront, conforms to the stereotypes of this sort of sex contrast. But that questioning gaze gives the picture an entirely personal cast. Taken with the blocking folded screen, it seems to propose that the whole image, but for the qualifying dark strip on the left of the canvas, is seen in a mirror; that Pierre Bonnard catches himself before, or after, going to bed with Marthe, his woman – for both faces are distinctly identifiable; and that his self-awareness, which is the necessary condition of his art, holds them apart. Yet it would be more accurate to describe the picture not as a mirror view but as a vision, for the perspective is centred not on the man's head but on the screen. Seen thus, the two figures are commemorated together in their reciprocity. A tender, intimate sense of equivalence in Pierre and Marthe's relationship at this period also shows in the photographs they took of each other outdoors, posing in the nude (Figs. 18 and 19).

Fig. 18
Photograph of Pierre
Bonnard in the nude
1900-1901. Musée
d'Orsay, Paris

Fig. 19
Photograph of Marthe
in the nude
1900-1901. Musée
d'Orsay, Paris

The Terrasse Family

1900. Oil on canvas, 139 x 212 cm. Musée d'Orsay, Paris

This picture dates from 1900, a juncture in Bonnard's career, and with hindsight can be seen as a juncture of the artistic manners of two centuries. Bonnard was beginning to turn his back on the Parisian scene he had been immediately involved with in the 1890s, moving from the relatively slight, insouciant productions of his youth to attempt more imposing canvases. The scene here gathers characters and familiar elements from the Bonnard family house at Le Grand-Lemps in the Dauphiné – the kind of close observation of leisured bourgeois life dear to the Impressionists – to make a complex, considered composition. But the cumulative effect is utterly different from Renoir's enticing images. The face-on front of the house establishes a rebuffing flatness, which the muted, uninviting glimpse of sky and distance to the right does little to break. The muffled light also deprives the doors and windows of depth. Held in this format – an atmospheric equivalent to the kind of flat coloristic unity Matisse was later to create – the figures of Bonnard's family and friends appear, all pulling in different directions. The languorously elongated form of his brother-in-law Claude Terrasse and the compact alertness of the child beside him each are in different, self-contained worlds; likewise Bonnard's sister Andrée, Claude's wife, in the red gingham dress, is only related to her stout elderly visitors M. and Mme Prudhomme in the most indirect way. The overall quizzical drollness has led to the picture being known as *The Bourgeois Afternoon*, as if there were a satirical intention. Bonnard rarely seems to have concerned himself with the titles of his paintings, which may well have been coined by friends or dealers.

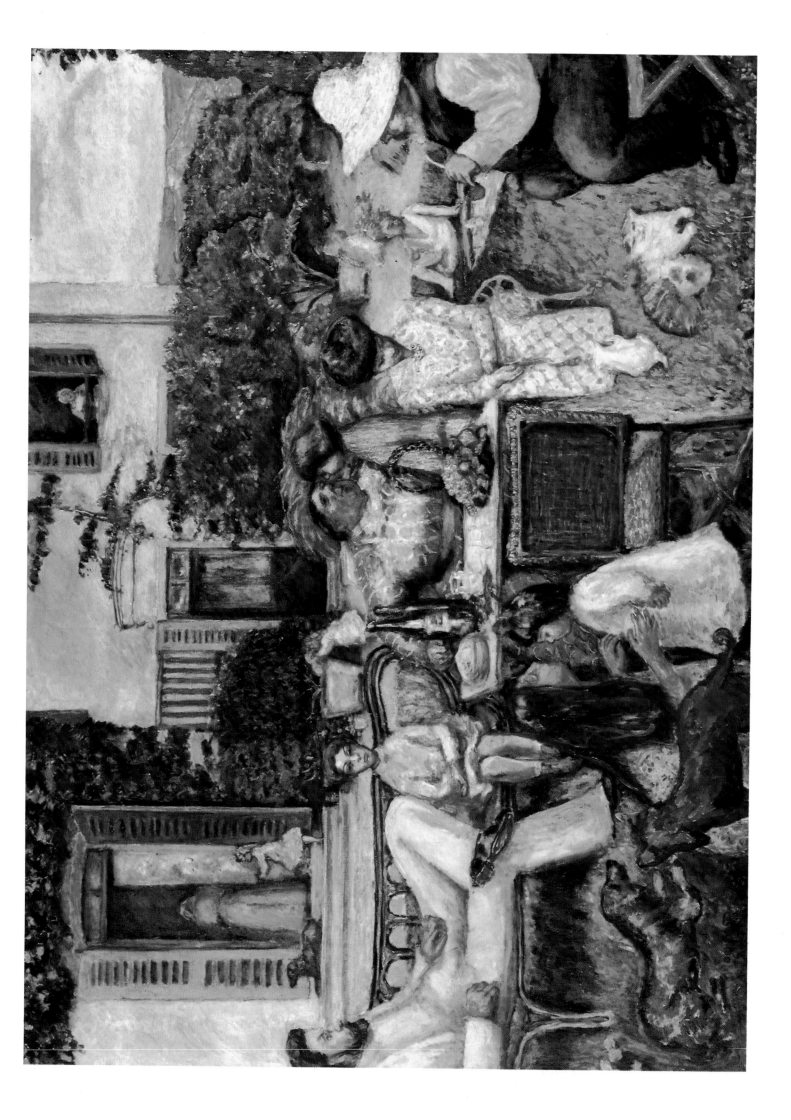

Ambroise Vollard

c.1904–5. Oil on canvas, 74 x 92.5 cm. Kunsthaus, Zurich

Ambroise Vollard was also painted by Cézanne and Picasso, among a host of artists whose careers he helped shape. He was a dealer of singular influence in Paris during the extraordinarily fertile period that spawned the Nabis, the Fauves and the Cubists. Having arrived there from the colony of Réunion in 1895 as a law student, he began by promoting the work of Cézanne but soon also took an interest in the work of Bonnard, among others; Vollard commissioned Bonnard to illustrate Verlaine's collection of verse, *Parallèlement*, in 1898. The boldness of Bonnard's engagement with this text seems to have bemused critics when it appeared in 1900 but, undismayed, Vollard immediately commissioned a further lithographic project, illustrations for the classical romance *Daphnis et Chloé*, which appeared in 1902. Later Bonnard was to illustrate a text written by Vollard himself, *Sainte Monique* (1930).

This portrait is from a period when Bonnard was setting out to prove himself an able producer of paintings in conventional formats, adopting Impressionist ways of working. Thus, unlike most plates in this volume it would have been painted largely directly from life: Vollard in his memoirs recalled 'I did not go to sleep [while being painted], for I had a little cat on my knees to stroke'. The painting on the wall behind him is probably one of Cézanne's groups of *Bathers*.

ÉTÉ.

Et l'enfant répondit, pâmée
Sous la fourmillante caresse
De sa pantelante maîtresse :
« Je me meurs, ô ma bien-aimée!

« Je me meurs : ta gorge enflammée
Et lourde me soûle & m'oppresse;
Ta forte chair d'où sort l'ivresse
Est étrangement parfumée;

17

Fig. 20
Illustration to
Parallèlement
1900. Lithograph in
pink sanguine

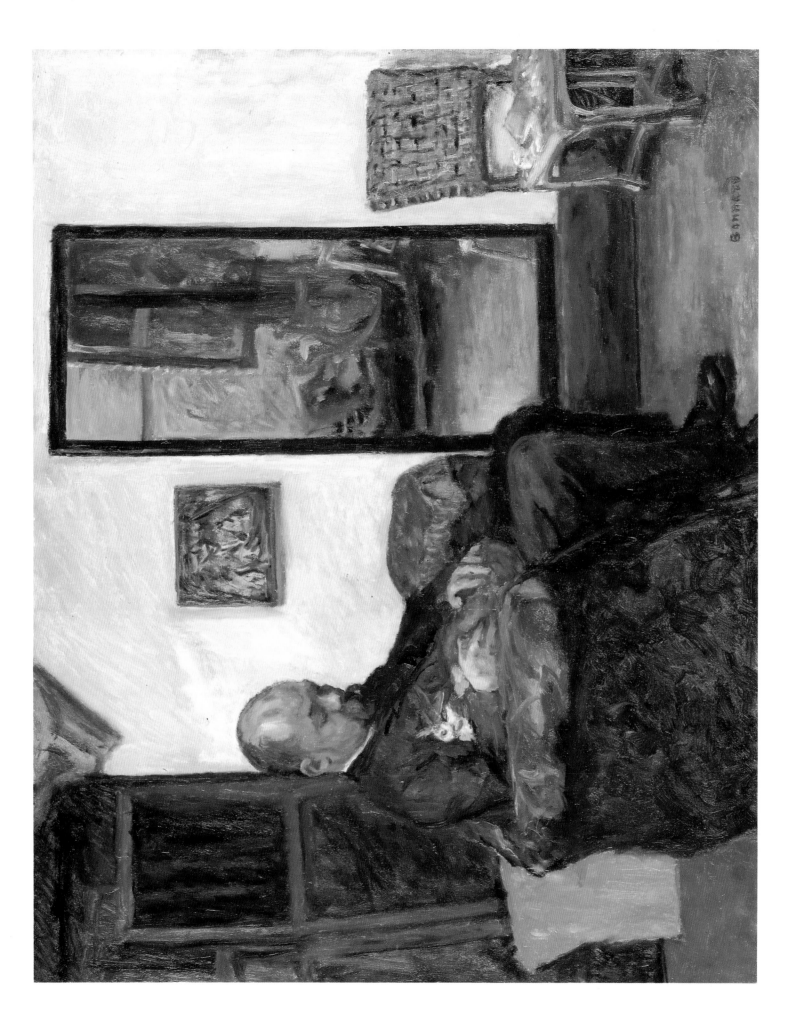

'Pleasure'

1906. Oil on canvas, 250 x 300 cm. Galerie Maeght, Paris

This is one of four panels painted to decorate the Paris apartments of Misia Godebska (see Plate 14). From the start of his career Bonnard had been interested in the possibilities of decorative painting; in his old age, although opportunities for such work had become few, he remarked 'I float between decoration and *intimisme*; one doesn't consign oneself'. Decoration offered him a chance to organize and combine the resources of his memory. Thus some of the figures here might originate from homely sketches of children playing at Le Grand-Lemps (where the garden contained a central pool), while the maidens with their fluttering drapery echo some classical or classicizing frieze, and the Chinese sage seated at the left seems to have stepped out of an eighteenth-century Rococo tapestry. The Rococo – a style which itself offered great freedom to combine heterogenous elements – is the crucial influence here; the panels were created to blend with furniture of that period in Misia's apartment, using the typically Rococo motif of monkeys in their borders. The thematic content linking the fantasies seems innocuous and vague: the other three panels, entitled *Travel*, *Play* and *Study*, contain similar dispositions of mythological characters and animals within imaginary landscapes. However, as painting, the works show a new coloristic daring, building on Bonnard's experience of working with earthy grounds, such as the cardboard in *Street Scene, Place Clichy* (Plate 5), to use a fantastical range of shimmering pinks and blues.

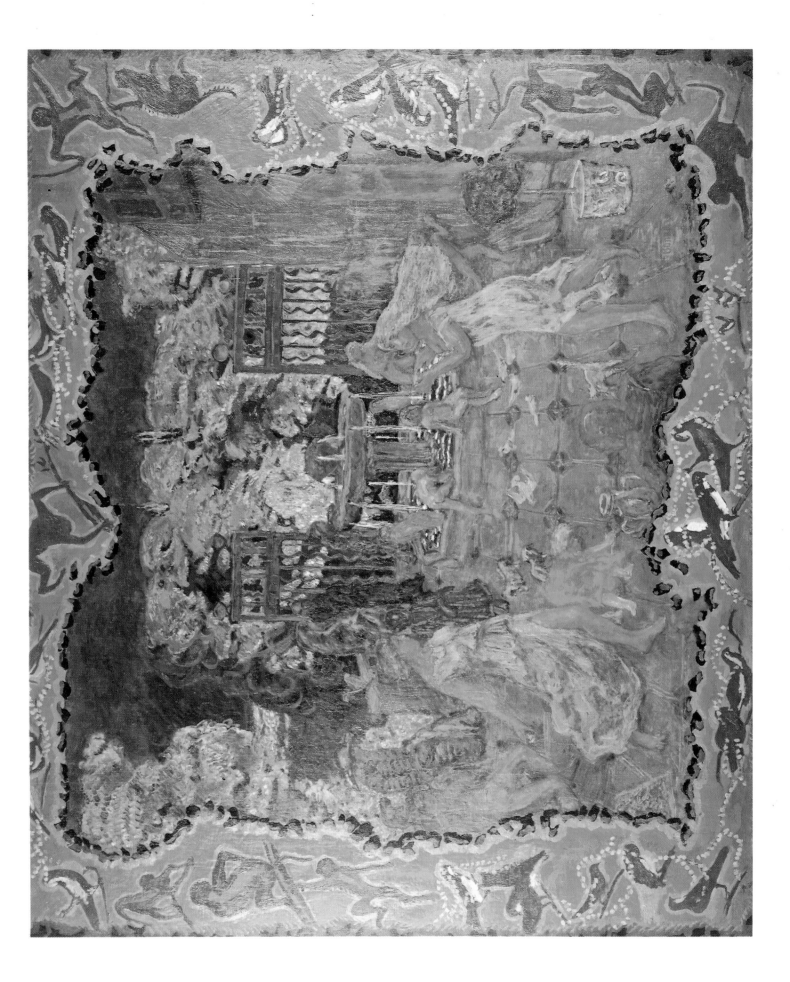

Nude against Daylight

1908. Oil on canvas, 124.5 x 108 cm. Musées Royaux des Beaux-Arts de Belgique, Brussels

Atmosphere and solid volume are for the painter two divergent possibilities: this big, generous image manages to do justice to both. Two elements impress equally – the flood of light through the lace down onto the bedding, and the poised strong body of Marthe, assertive and definite in her enclosed world – an enclosure redoubled by the mirror. Bonnard's drawing of the body is lithe and rhythmic, with a respect for the physical self-sufficiency of his companion. Typically, she is seen spraying herself with perfume (the picture has also been known as *The Eau de Cologne*): Bonnard often liked to show his model attending to her own body, scrubbing and grooming, as if to appeal to an inward reality of self beyond the picture, established by touch. However, the daylight is the basis of the paintwork, a great diffusion of brightness against which local hues such as the turquoises and pinks subordinately emerge: set against Marthe's body, it amounts to an assertion of the painter's power to give this particular space around her this particular meaning. In this treatment of light the painting marks the furthest extent of Bonnard's transactions with Impressionism, and looking back on his career he was to see it as the major achievement in this phase of his work.

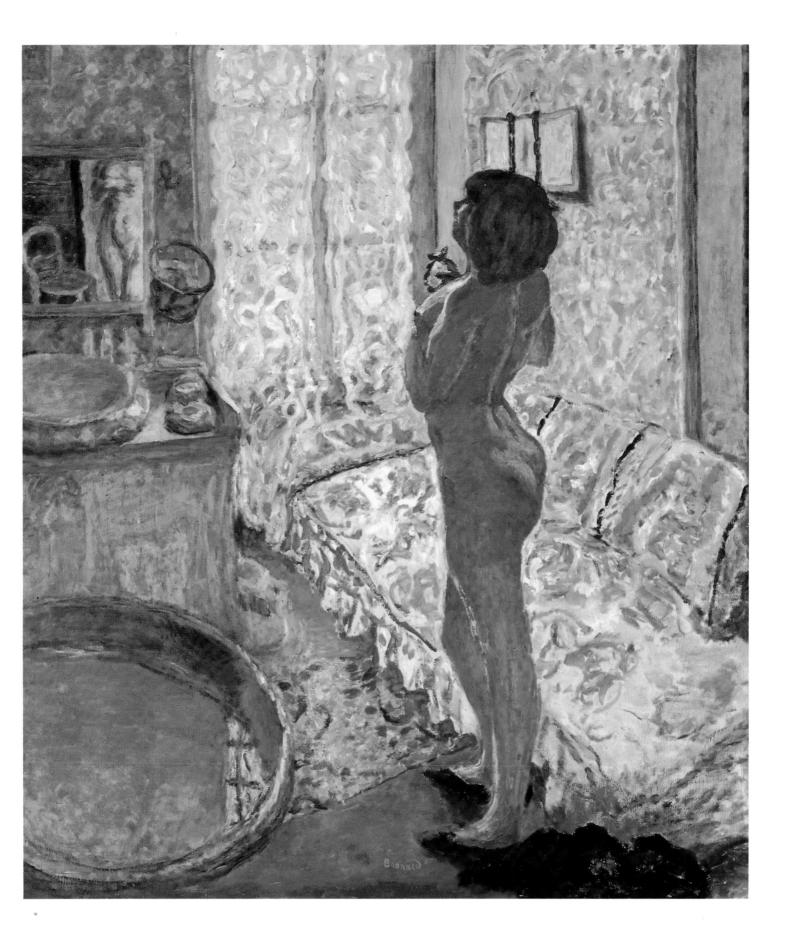

Misia

1908. Oil on canvas, 145 x 114 cm. Thyssen-Bornemisza Collection, Madrid

Misia, the daughter of the Polish emigré sculptor Cyprien Godebski, initially performed as a pianist. After marrying Thadée Natanson, the editor of *La Revue blanche* (see Plate 4), she hosted a salon of Paris's fin-de-siècle luminaries – Mallarmé, Debussy, Renoir – as well as young Nabi painters such as Vuillard, Félix Vallotton and Bonnard himself. Misia's glamour encouraged an ambience of fantasy and cultural nostalgia in her entourage, as seen in Bonnard's decorations for her apartments, done in 1906 (Plate 12). The *Revue* had folded three years before that date and Natanson had been faced with financial ruin – a predicament from which he was rescued by the newspaper magnate Alfred Edwards, on condition that he surrender up his desirable and feckless wife. Misia went on to a third marriage with the painter José Maria Sert.

The portrait is one of Bonnard's most adept efforts at flattery, using the mix of Nabi muted ground with Impressionist light that he had developed during the 1900s to flamboyant effect. A pen sketch exists of Misia naked in a similar pose.

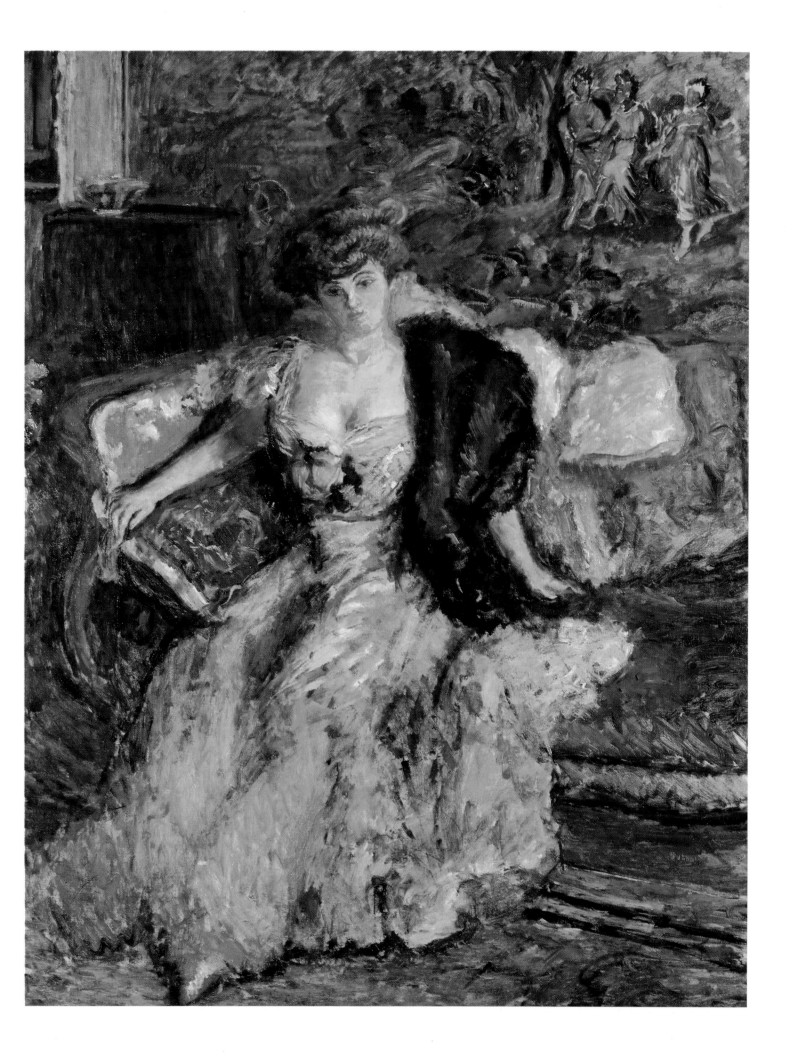

1908. Oil on canvas, 115 x 123 cm. Private collection

The meal outside is a subject tailor-made for the kind of Impressionism Bonnard was thinking in terms of during the 1900s. During that decade he had become acquainted with Renoir in a respectful friendship ('like a strict father', in Bonnard's reminiscence) and Monet, whose house at Giverny was in the area of the Seine valley that Bonnard frequented. Much of the work of this picture is concerned with the rendition of light – the bleaching of the cloth at Marthe's shoulder, the glints in her hair and on the bottle, the flickering of the foliage. However, that foliage sets a check on the naturalism, a curiously reconstituted screen blocking the distance proposed by the recession of the table. At cross-purposes to this dialogue of surface and depth, there is a sideways story going on, light and playful but allowing for a certain mystery in the dog's blackness and his obscure relation to the muzzy entrant behind the deckchair.

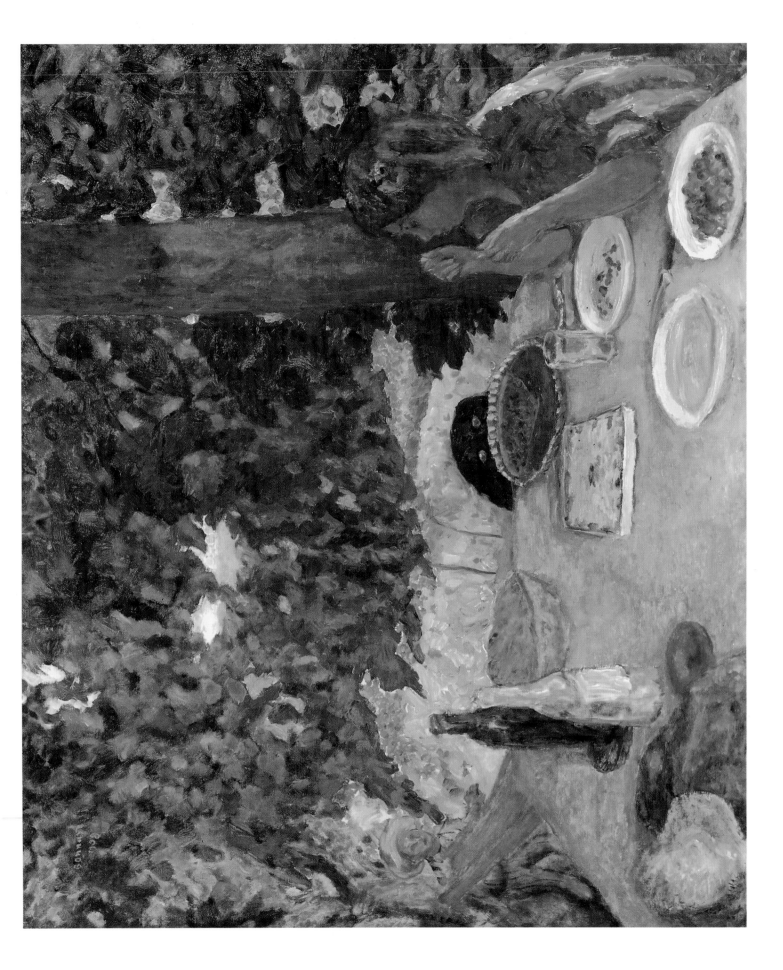

Early Spring

1908. Oil on canvas, 87.6 x 132.1 cm. Phillips Collection, Washington, DC

Colour by colour, detail by detail, the scene sparkles with sensitivity to observed nature. The particular season is distinctively caught, with its flickering light, vivid twigs about to bud and early flowers such as *The Pansies* (an alternative title) at the foot of the canvas. The drawing that underpins all this, however, is by no means naturalistic: the angles of the red-roofed house and the flowerbed obey child-like preconceptions. Is their child-likeness of a piece with the child who enters from the right and makes the scene her own: is the whole picture 'her world', alluding to her frail youthful hopefulness, her playfellows, her vistas; as if *Les Pensées* should be translated not as 'pansies', but as 'thoughts'? Such a way of reading pictures would be familiar to members of Bonnard's generation, accustomed to Symbolist paintings and poetry in which the outward landscape was chiefly a register of the inward state of mind but, unlike Gauguin or his Nabi colleague Maurice Denis, Bonnard never forces the issue; we are at liberty to read the relation between the girl and the landscape the other way round, seeing her as an afterthought distilling and giving focus to the season.

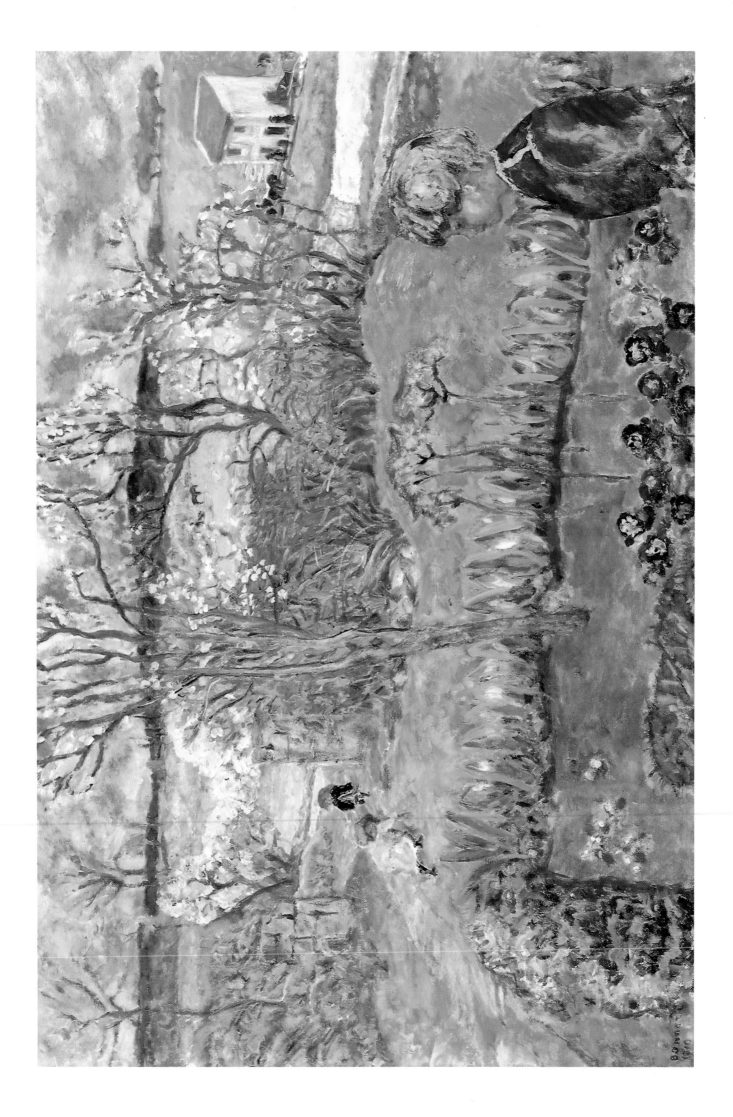

The Little Fauns

1909. Oil on canvas, 103 x 126 cm. Hermitage, St Petersburg

Compacting a broad stretch of countryside in the Seine valley into a curving recession, hinged upon the bend of the road, Bonnard has found a foreground vacancy that seems to demand figures. He has filled it with the mythical creatures whose advent traditionally heralds spring and new stirrings of lust (a theme for which he had a recurring fondness; it is also treated in a jocular collaboration with Alfred Jarry, *Soleil de printemps*, 1903 (Fig. 7). This kind of classicizing touch had been part of Bonnard's repertory since he illustrated the Greek romance *Daphnis et Chloé* in 1902, and it dominated the work of his friend Ker-Xavier Roussel. Fauns, in particular, were a stock property for artistic allusion following Mallarmé's famous eclogue *L'Après-midi d'un faune* of 1876. Appeals to classical culture as a repository of value were an important element in French cultural debate in the early decades of the century, often being made as part of a reactionary rhetoric. But, obviously, Bonnard's pictures are far from being polemical interventions, and this is an instance of his work at its most amenable. As Francis Jourdain put it in his memoirs: 'If this prisoner of the "virgin, bright and beautiful today" [Mallarmé's phrase] may wander off to seek out some personage from the past, that figure has always the air, like Bonnard himself, of being born at Fontenay-aux-Roses, and his little fauns look like urchins from the avenue de Clichy.'

Fig. 21
Illustration of Chloe
garlanding Daphnis
from *Daphnis et Chloé*
1902. Lithograph

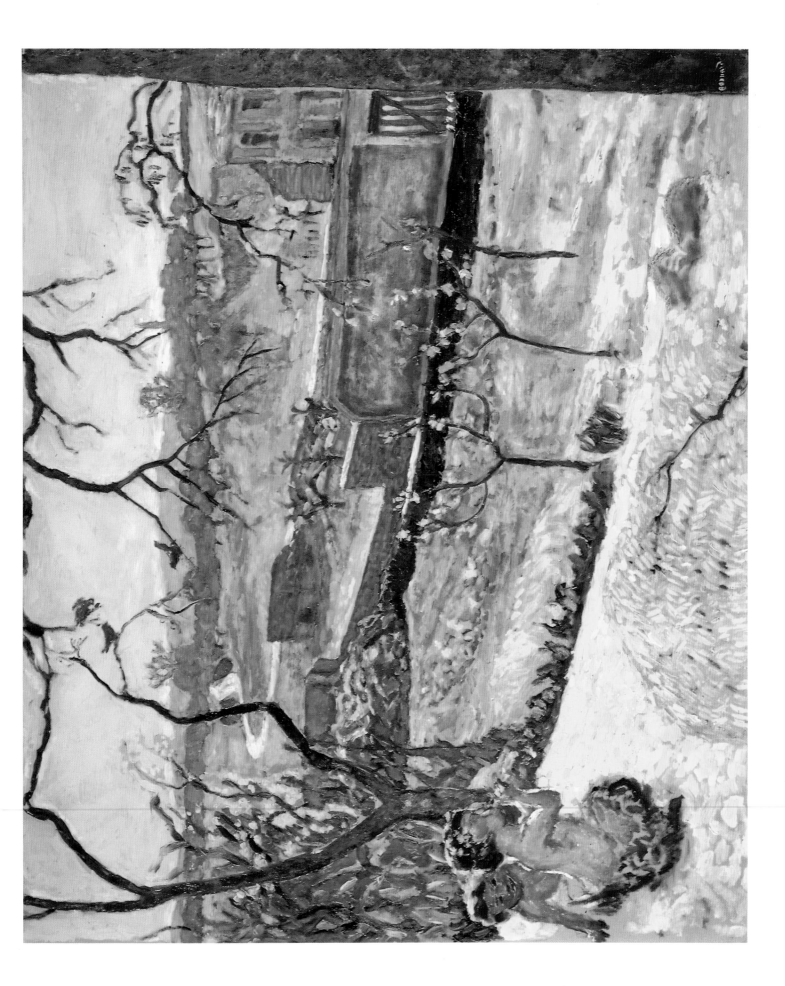

Reflection in the Mirror

1909. Oil on canvas, 73 x 84.5 cm. Private collection

It is almost like a joke, or a startling figure of speech. The picture's claim to represent solidity and spatial depth is thrown back in its face; it is in truth doubly a flat thing, a painted canvas of a silvered glass. Almost; the angle of vision stands between emphatically, introducing the brush and bottles below the receding frame, seeming less substantial than what is merely reflected. That perspective thrusts the viewer by the scruff of the neck into the painter's close privacy with his woman. The knowledge he conveys of her is sure and carnal, but not glamorous, not flaunted.

Mallarmé's poetry, which Bonnard loved and would recite at length, often uses the mirror as a fulcrum for meditation, a symbol for the indefinitely self-reflexive processes he took to be inherent in art. This is one of the earliest and most immediate of a host of pictures Bonnard painted in his forties in which he explored the possibilities of reflection: the persistence of the motif came to indicate a musing unease about 'art' and picture-making, a kind of recourse to visual quotation marks.

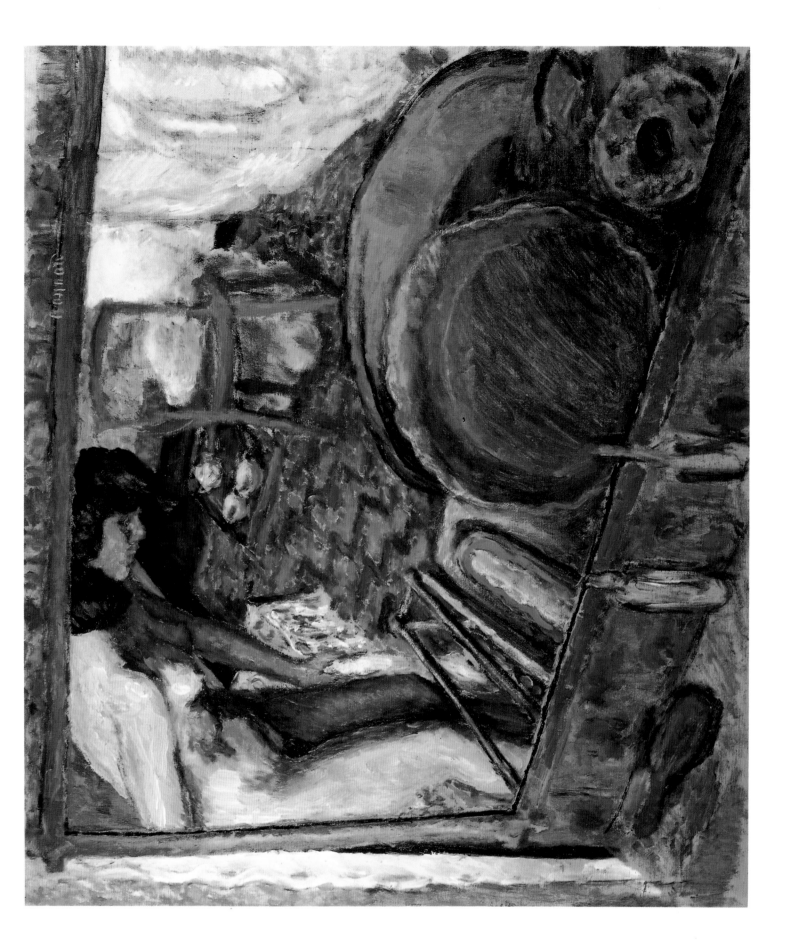

1910. Oil on canvas, 83 x 85 cm. Private collection

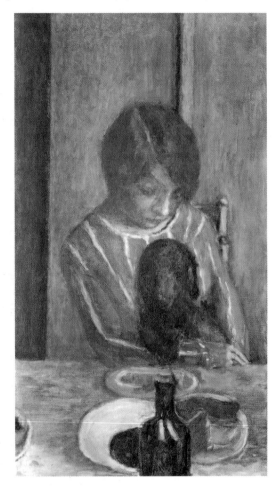

Fig. 22
Woman and Dog
1891. Oil on canvas,
30 x 32 cm.
Phillips Collection,
Washington, DC

This is part of the central, familiar terrain of Bonnard's painting, classically formulated: woman, dog, table-top; everything steeped in a tender, modulated melancholy. It is a ground he returns to unwearyingly (see also Fig. 22). A single obsessive detail breaking out from the economy of effect – the glimpse of the chair's coloured basketwork behind her shoulder – only serves to emphasize the restraint of the rest. The red checkers are a motif that runs through Bonnard's whole career, from early portraits of his sister in a blouse of that pattern to late still lifes like *Basket and Plate of Fruit on a Red-checkered Tablecloth* (Plate 44). They begin as a way of emphasizing the flat decorative possibilities of the image and become a rhythmic structure underpinning his whole way of seeing. The British painter Patrick Heron has written of Bonnard's 'all-over' vision of the pictorial field, as if he had caught it in a fish-net, 'an imaginary structure of loose connected squares over his vision'. It is a grid implicit in Bonnard's steady breadth of attention in paintings like *The Open Window* (Plate 27); when relayed explicitly, as here, it often recedes in perspectives to make a slight but interesting tension with the picture's flatness.

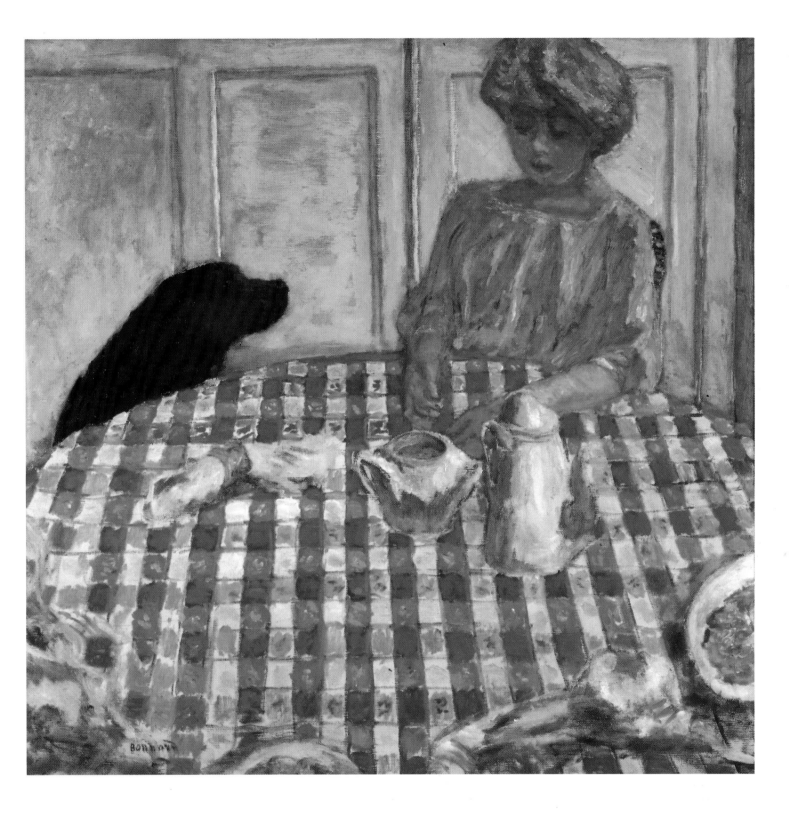

Woman with Parrot

1910. Oil on canvas, 104 x 122 cm. Private collection

Bonnard wrote to his mother in 1910 about being invited to stay at a friend's house near the Mediterranean: 'The South was a very alluring idea, and when I got there it was like something out of the Arabian Nights. The sea, the yellow walls, the reflections as full of colour as the light. After a fragrant midday meal we went to call on some neighbours and I had a vision of a very dark girl in a pink dress down to her feet with an enormous blue parrot, uncaged, against the yellow, red and green background.' The South of France seems to have filled a waiting niche in Bonnard's imagination. The elements of his vision of it are already present in the 1906 decorations for Misia (Plate 14) – the eclectic mix of old civilizations, the longing for a life characterized, in Baudelaire's famous phrase, by '*luxe, calme et volupté*'. His response to this first encounter with the South in 1910 is florid in its enthusiasm. He followed it by repeated visits to Saint-Tropez and Antibes during the following decade, eventually settling in the area in the 1920s.

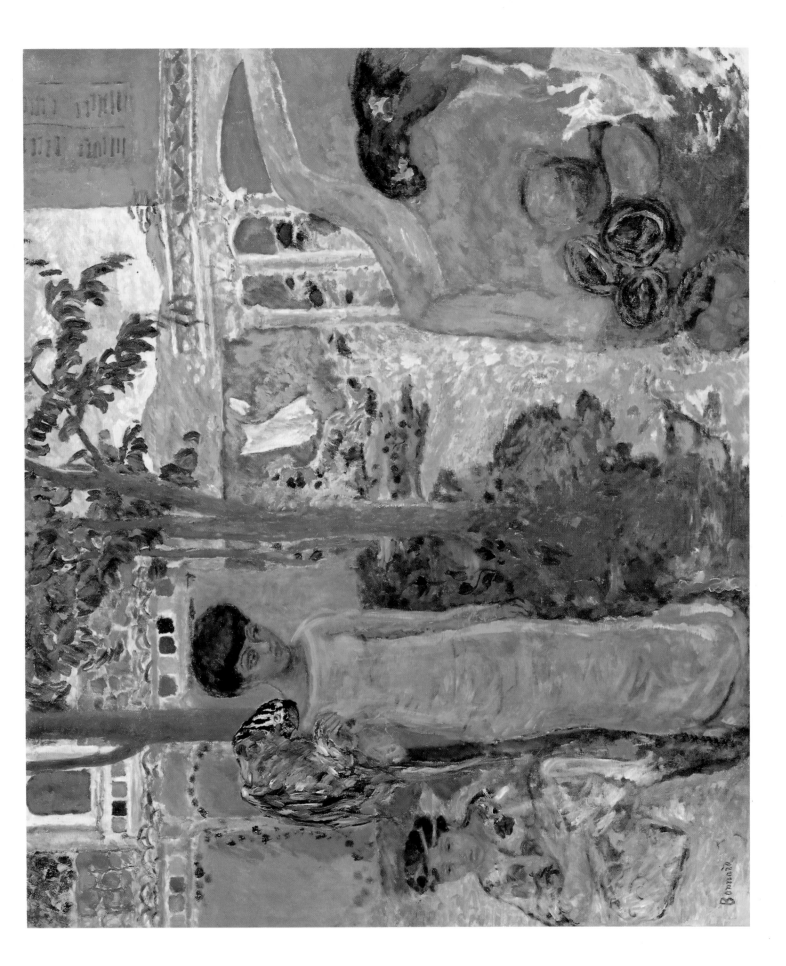

The Place de Clichy

1912. Oil on canvas, 139 x 205 cm. Musée des Beaux-Arts et d'Archéologie, Besançon

Fig. 23
Movement of the
Street
1901. Oil on canvas,
36 x 48.8 cm.
Phillips Collection,
Washington, DC

Bonnard continued to rent studios in Paris throughout his life, although after 1900 he came to spend less and less time in the capital. He remained close to the area he had known since student days, the lively and informal streets of lower Montmartre (Plate 5). His later images of it, such as Fig. 23, became more considered and comprehensive than the fragmentary *aperçus* of the 1890s: they have acquired a sort of solidity through the weight of memory infused into them. At the same time, this view from behind a café window is full of the immediate life and movement of a bright day in 1912. In his imagery Bonnard rarely insists on contemporary detail like the motorcar, but nor does he avoid it: 'One can find beauty in everything', he was to say. The border of lettered awning is a framing, distancing device with many relatives in Bonnard's work, from the *Man and Woman* of 1900 (Plate 9) to *The Boxer* of 1931 (Plate 40). The picture was painted for Bonnard's friend the critic George Besson: a companion piece showing the place de Clichy by night was commissioned in 1928.

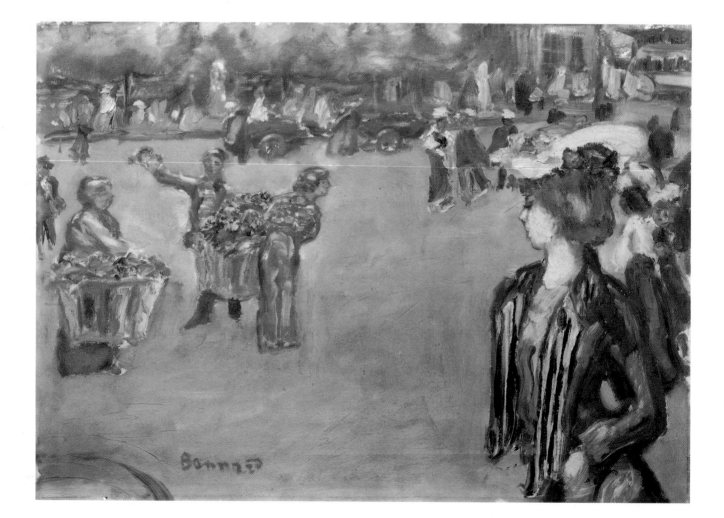

1913. Oil on canvas, 168 x 204 cm. Institute of Arts, Minneapolis, MN

Fig. 24
Nude in Front of
the Fireplace
1914. Oil on canvas,
dimensions unknown.
Whereabouts unknown

This large canvas, a view from within the property Bonnard had bought in 1912 at Vernonnet in the Seine valley, was a landmark in his development. In his mid-forties, round about 1912, he went through a period of fierce self-appraisal, perhaps under the pressure of the Cubist revolution that seemed to be declaring his manner obsolete. As he later described this crisis of confidence to his nephew Charles Terrasse, he came to think that he had pursued 'colour' too far. 'I was almost unconsciously sacrificing form to it.' The solution, he determined, was to re-educate himself. 'I wanted to forget all the things I knew and know.' He would concentrate on drawing. 'And after drawing comes composition. A well composed painting is half done.'

Dining-room in the Country was, in Terrasse's account, the first major painting to benefit from this re-education. The problem with Bonnard's remarks – probably made some 15 years later – is to understand what the 'colour' was that had distracted him. It is true that work like the *Woman with Parrot* of 1910 (Plate 20) is almost fulsomely colourful, but the same might be said of the present painting, with its extraordinary modulations of hot and cold, red flowers against the red wall, the table-top cool as a glacier slowly tumbling. What seems to have changed is the meaning of colour. In the earlier painting the palette mimics or evokes the observed world, the elements of which are seized on almost by happenstance. Here a firm, capacious structure, the product of Bonnard's new emphasis on drawing, underlies every passage of paint; given that secure basis, he is able to develop harmonies and contrasts of an unprecedented daring. Colour here serves not nature but the autonomy of the picture; in a singular and personal way, Bonnard has answered the threat posed to his validity as an artist by the rise of Cubism, asserting his alignment with a principle of Cubist aesthetics.

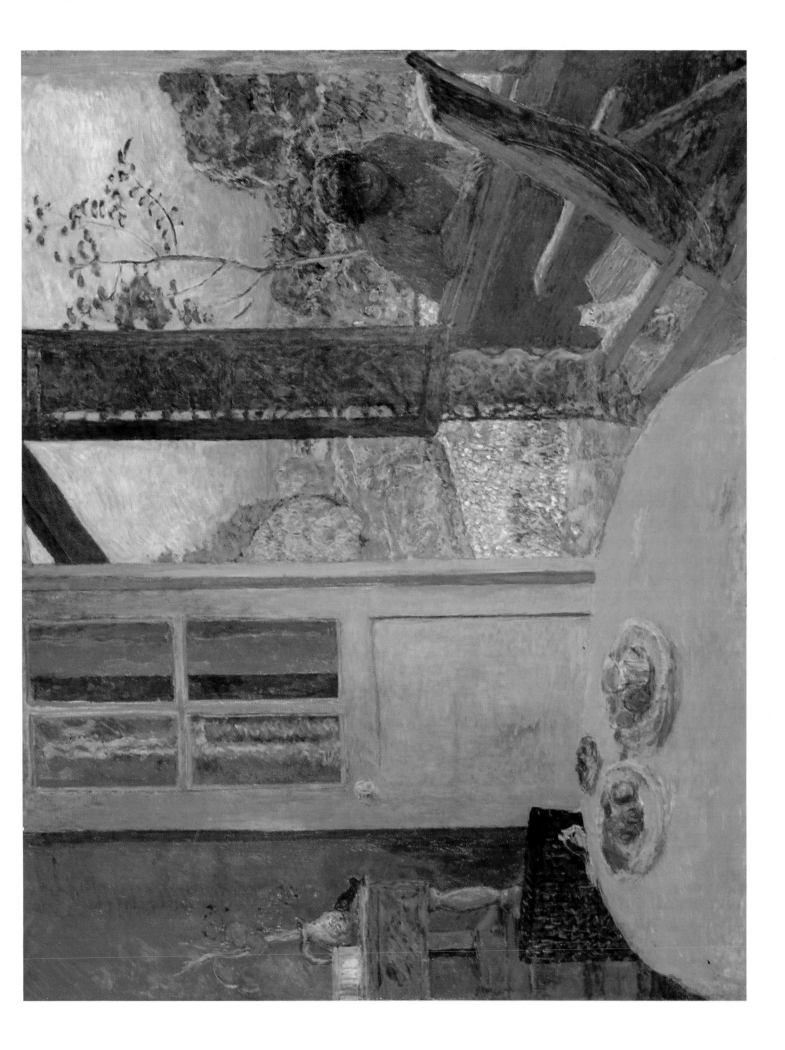

Pastoral Symphony

1916-20. Oil on canvas, 130 x 160 cm. Bernheim-Jeune, Paris

This is one of four panels commissioned by the Bernheim-Jeune family to decorate their private apartments in Paris. The ensemble gave Bonnard another opportunity, after the panels for Misia Godebska ten years earlier (Plate 14) and work for the Russian collector Ivan Morosov in 1913, to explore and organize his own imaginative world. The results are graver and more considered than the earlier pieces. They are arranged in oppositions of ancient and modern, city and country, northern and southern landscape. Besides the panel here, Bonnard painted *The Earthly Paradise*, with Adam and Eve innocent and awestruck at the dawn of time; *Monuments*, a de Chirico-like view of a Mediterranean port with references to classical civilization; and *The Workers at La Grande Jatte*, in which, uncharacteristically and rather clumsily, contemporary workmen make an appearance. *Pastoral Symphony* represents an idyllic vision of country life – of peaceful plenitude and complaisant beasts – that had been latent in Bonnard's imagination since his childhood holidays at the family's country home in the Dauphiné. The particular scene here, however, more resembles his current dwelling in the Seine valley.

The woman canoodling with the stag prods the picture in the direction of classical mythology. The goddess Diana, enraged by Actaeon's chance vision of her bathing, turned him to a stag: but Bonnard is too tentative a storyteller to make it clear whether he has in mind here some subsequent rapprochement between the two, or else some reference to the stag of French royal heraldry. What is emphatic is the vision of high summer colour, almost foreboding in its intensity. Bonnard was working to uphold a personal vision of beauty, defensively perhaps in an epoch of insistent grimness.

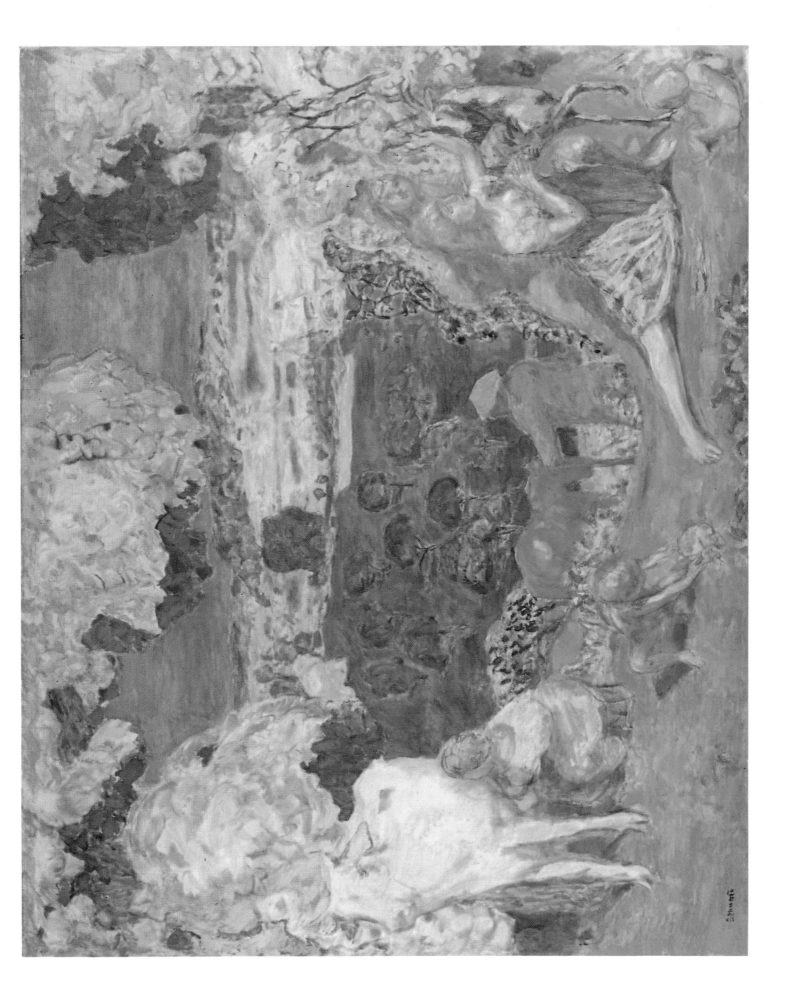

The Terrace

1918. Oil on canvas, 159.5 x 249.5 cm. Phillips Collection, Washington, DC

The image slowly coils itself round the entwined ornamental trees at the centre, their union seeming to echo or to symbolize that of the elderly couple beside them. But this is merely the focal incident in a grand extensive field rich with strange incidents of paint – the various livid reds hit by the flowerpots and the far houses, the way the mass of foliage on a sapling has headed towards a saturated blue. A view filled with verdure has become anything but green. As in *The Cherry Tart* (Plate 15), Bonnard is fascinated by the impermeability of the leaves as a screen, forming a backdrop behind a central incident of affection. This is a development of the manner announced by the *Dining-room in the Country* (Plate 22), and was likewise painted at Ma Roulotte, Bonnard's house at Vernonnet. The features of this unassuming country villa – named 'my caravan' by a previous owner, an address it suited Bonnard to stick with – were the occasion for many paintings, with many more sketches behind them (Fig. 25). The masterfulness of Bonnard's composition in the *Terrace* may be seen in the way he dovetails the foreground table into the rhythms of the picture, effortlessly breaking and restarting its curve at the waterjug.

Fig. 25
The Terrace at
Ma Roulotte
c.1928. Pencil,
27.5 x 30.5 cm.
Private collection

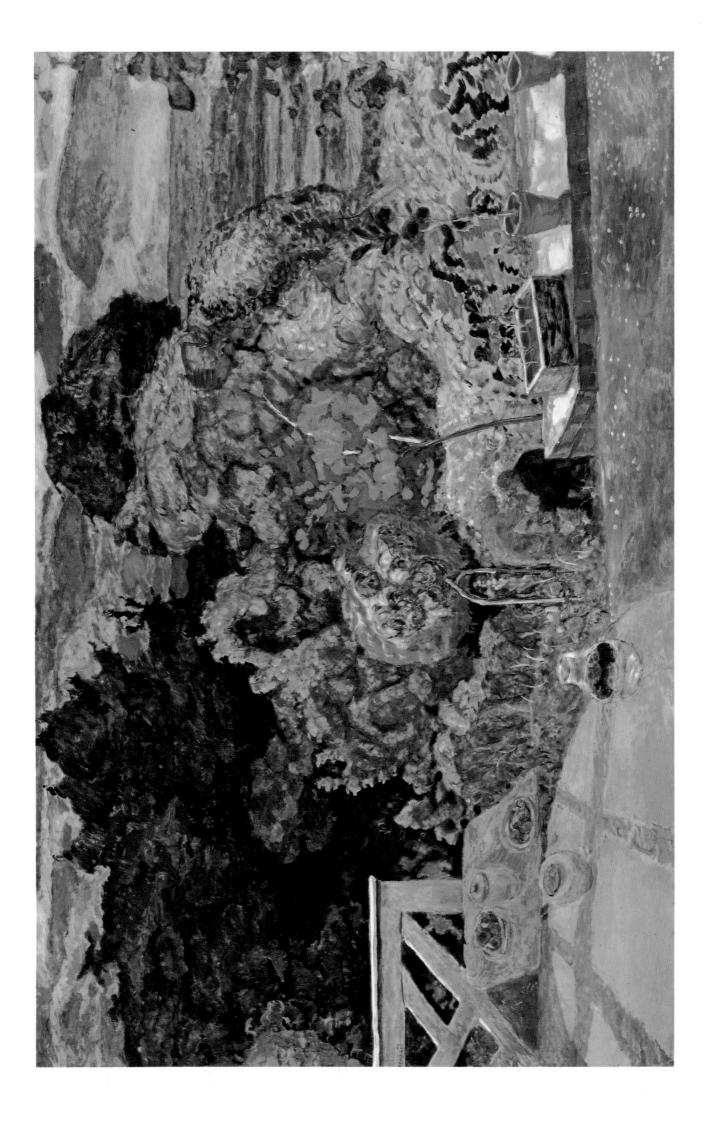

c.1919. Oil on canvas, 116.2 x 121.6 cm. Tate Gallery, London

'He became a dreamer, a solitary', wrote Charles Terrasse in 1927, describing his uncle's later career. This grand, melancholy painting seems to occupy a borderline between the everyday observation that underlies paintings like *The Red-checkered Tablecloth* (Plate 19) and a visionary interior world. Ostensibly the incident is a drink for the cat scribbled in at the picture's base. The scene is from Bonnard's apartments at Antibes, where he was frequently staying in the late 1910s – the Mediterranean glints through the window. But the girl bearing the bowl, with her mysteriously occluded eyes, seems to have stepped out of the classicizing dreams invoked by Giorgio de Chirico and his successors in the Surrealist movement. The resultant mood, while perfectly distinct, resists translation into prose, though one may note the element of claustrophobia induced by the heavy anemones and raw sienna walls and emphasized by the polished table-top's salient nearness. Bonnard wrote about nearness as a component of his vision:

'I stand in a corner of the room, near to this table bathed in sunlight. The eye sees distant masses as having an almost linear aspect, without relief, without depth. But near objects rise up towards it. The sides trail away [*filent*]. And these shifts are sometimes rectilinear – for what is distant – sometimes curved – for planes that are near. The vision of distant things is a flat vision. It is the near planes which give the idea of the universe as the human eye sees it, of a universe that is rolling, or convex, or concave...'

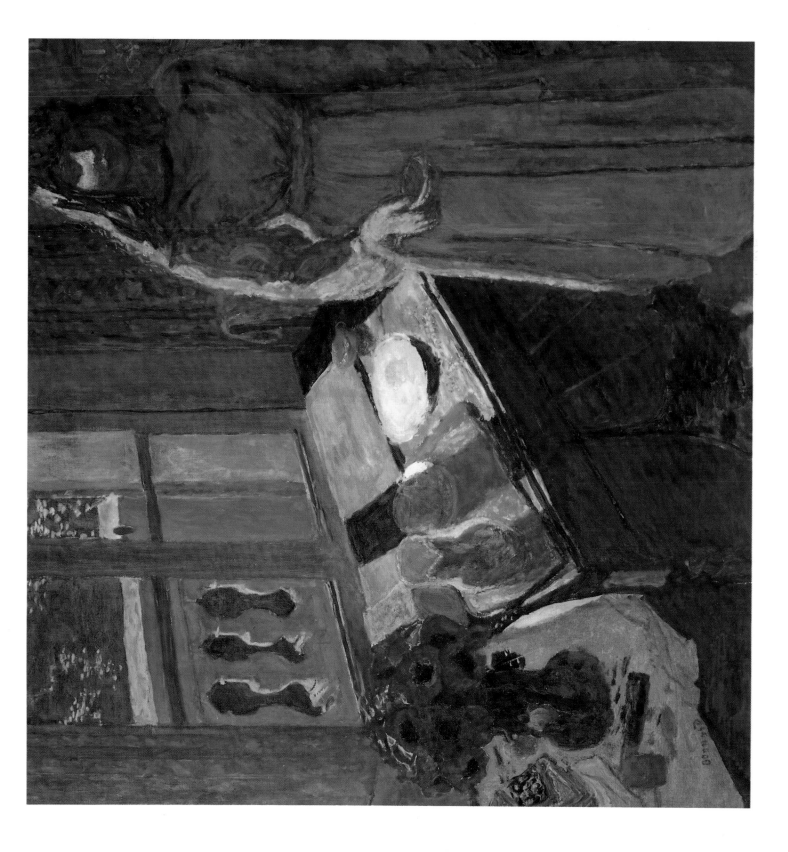

Josse Bernheim-Jeune and Gaston Bernheim de Villers

1920. Oil on canvas, 165.5 x 155.5 cm. Musée d'Orsay, Paris

The two dealers here inherited an important position in the contemporary art market in Paris from their father, Alexandre Bernheim. To his roster of senior Impressionists such as Monet and Renoir they added, from 1901, many of the Nabi generation, including Bonnard, Vuillard, Roussel and Félix Vallotton (who secured his position by marrying the Bernheim's sister). Bonnard's first one-man show at their gallery in the rue Richepanse was in 1906; thereafter he showed annually until the outbreak of the First World War. The brothers had first refusal on his paintings and acted as his bankers, an arrangement that seems to have kept him in financial security at least until the French financial crisis of the mid-1920s. Initially Bonnard's engagement with the Bernheim-Jeunes and their sleek haut-bourgeois milieu coincided with a desire to produce conservative, amenable canvases in traditional genres, and his annual 30-odd exhibits included quantities of exercises in landscape, still life and portraiture. However, there is nothing concessionary about the account he gives of them here in their office. His art has committed itself to stretching both the field of attention and the palette to the utmost, tackling the challenge of a near-square format head-on. The likenesses are summarized with almost caricatural disdain; put in their place, magnificently.

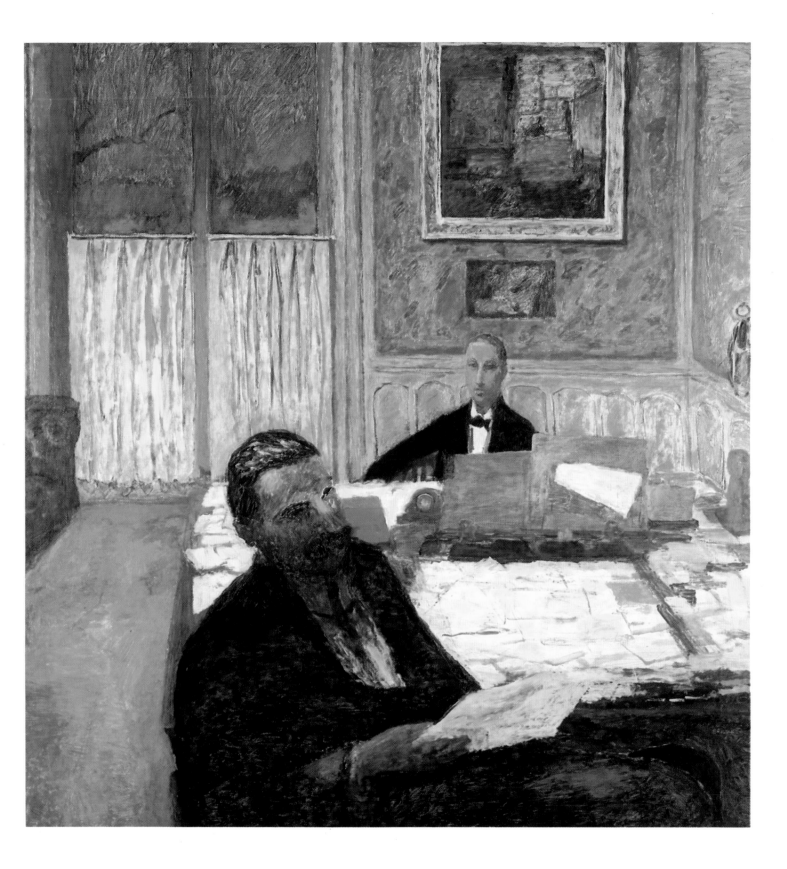

The Open Window

1921. Oil on canvas, 118 x 96 cm. Phillips Collection, Washington, DC

Heavenly light, as hundreds of Baroque Assumptions and Saints' Visions affirm, is its own raison d'être, but only becomes interesting pictorially when set against something different and dark. The vision of endless sun-filled blue, the first impulse communicated by this painting, tells on us because of all the other things it is not, which initially we hardly register. For instance, the woman playing with the cat comes as an afterthought. In this way Bonnard's run of masterpieces of the 1920s and 1930s, deliberately allowing for delays and successivities in attention, starts to incorporate mental time into the structure of the picture. Having made this dramatic calculation, however, the painter must make good his subject by a continuous even attention in every part. In this way, through the progressive accentuation of colour, inner and outer, first focus and afterthought become reconciled and equivalent. The view is from within Bonnard's house at Vernon in the Seine valley.

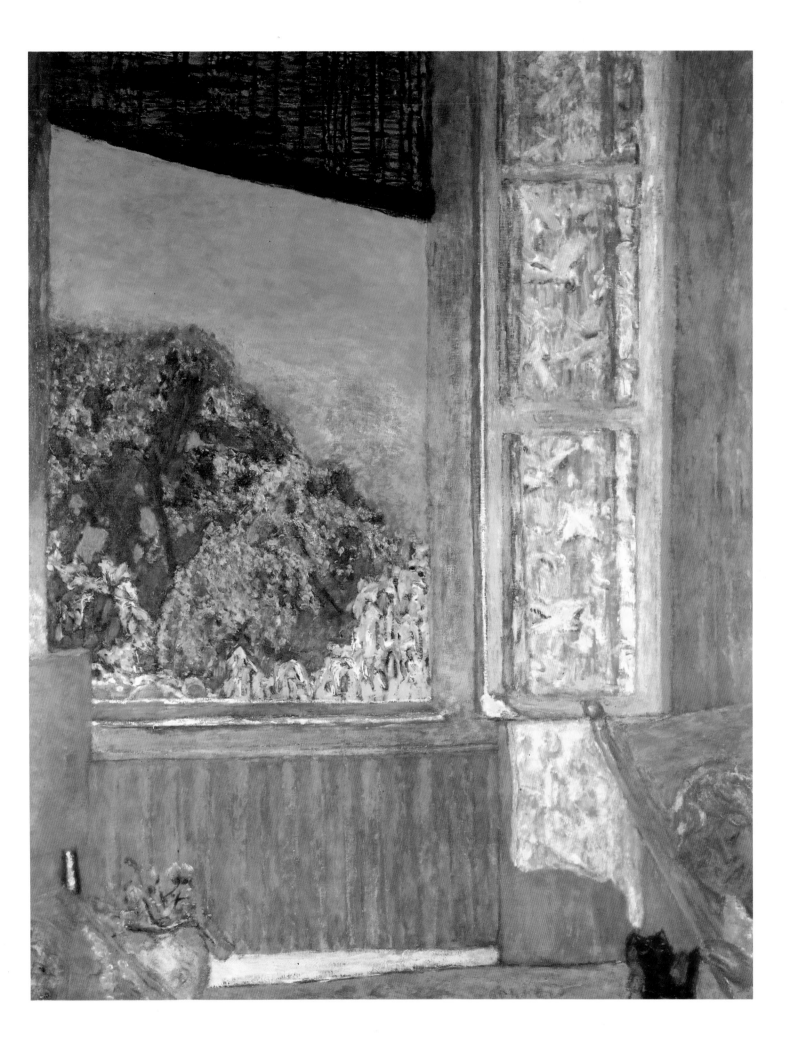

Young Women in the Garden

1921-3, reworked 1945-6. Oil on canvas, 60.5 x 77 cm. Private collection

There is an archaeology to this canvas. A layer of paintwork from the 1940s evokes the garden, using a range of yellows, pinks and viridians similar to that in the *Large Landscape in the Midi* (Plate 45) to capture as much as possible of the power of natural light. Beneath it lies an image of the early 1920s, the period preceding Bonnard's marriage to Marthe. It has, as Laure de Buzon-Vallet remarks (in S. H. Newman, 1984), 'a snapshot-like quality of spontaneity', though Bonnard's own photographs tend in fact to be more conservative, less inclined to the dramatic cutting-off of figures than his paintings. Despite this casual, snatched quality – no explanations given for the dark green shape that keeps the scene contained on the left – the configuration has an unmistakable emotional logic. You are looking past the presences, familiar, cornered and vague, of Marthe on the right and the dachshund on the left, to that clinching seductive gaze and behind it a prospect of luscious fruit: 'you' being a middle-aged, not quite married man with a sentimental streak. At the lowest stratum are biographical details that await further excavation. Renée Monchaty, the blonde girl gazing, modelled for Bonnard from about 1917. When she went to live in Rome Bonnard visited her, painting one of his few foreign scenes, *16 Piazza del Popolo* (Fig. 26) from sketches made there in 1921. On his last visit, in 1923, she killed herself: he found her lying dead in the bath.

How, then, to look at Bonnard's paintings of *The Bath*? He kept the painting with him in his studio for the rest of his life: the gilding of the garden in the 1940s can be seen as an attempt further to hallow what had become not only a memory, like any of his paintings, but a memento.

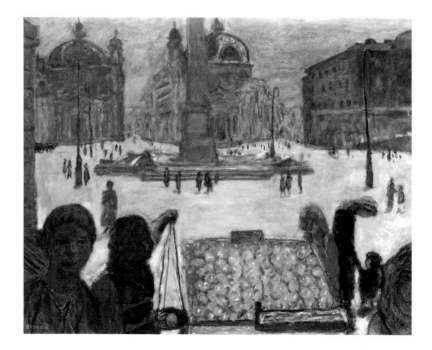

Fig. 26
16 Piazza del Popolo
1921-3. Oil on canvas,
79.5 x 96.5 cm.
Phillips Collection,
Washington, DC

c.1923. Oil on canvas, 79 x 76 cm. Phillips Collection, Washington, DC

The landscapes Bonnard painted throughout his life offered, like his still lifes, a comparatively straightforward opportunity to convert raw optical information into paint, to extrapolate from it the factors that would make something eloquent as a picture. Here, facing the Bay of Cannes, looking towards the mountains of the Esterel, he has set to work on a broad field of vision: it includes the screens of foliage that he liked to dwell on but also opens out into the deep distance that in other paintings they often block. A host of scattered inventions of the brush – oranges, blacks and viridians – are held together by an insistent emphasis on the light which had drawn Bonnard to the South of France. This light has been not merely recorded but reimagined. Bonnard later noted: 'As Delacroix wrote in his diary, "One never paints violently enough". In the light experienced in the South of France, everything sparkles and the whole painting vibrates. Take your picture to Paris: the blues turn to grey. Seen from afar, those blues also turn to grey. Therefore one thing is necessary in painting: heightening the tone.'

1920-39. Oil on canvas, 147 x 192 cm. Metropolitan Museum of Art, New York

This large, dauntingly mysterious picture may have been intended for some decorative scheme, as a title given it in the Daubervilles' catalogue raisonné suggests, or may have arisen from some particular observation made at Bonnard's house at Vernon in the Seine valley. It at once invites and baffles narrative interpretation. Is the central figure, bemused by the fruit she bears and shadowed by a basket-bearing alter ego, Marthe, and are the chatterers on the balcony and the dramatic entrant on the right (sword-wielding? fly-swatting?) forces that obscurely threaten her but remain becalmed in the painting's flatness? And what have the rowers on the Seine to do with it? Exact answers are probably not available; the picture may be one of those images that haunt an artist, beckoning him to return and re-elaborate, without ever declaring their explicit meaning. What is evident is the way Bonnard's paintwork has become a matter of shifts, beautiful transitions of colour and space that bypass perspectival logic; as if the sense of the painting hung not on the imagery but on the experience of passage and alternation.

The Sailing Excursion

1924. Oil on canvas, 98 x 103 cm. Private collection

Bonnard enjoyed sailing and produced several paintings from jottings made in his pocket notebook while seated supposedly with a hand to the tiller. His feel for the space here is full of the contrast of bodies jostling claustrophobically on board with the great openness of the sea beyond them. The painting was done as a portrait of the Hahnlosers, a family whose patronage did much to establish a reputation for Bonnard in Switzerland and who became his neighbours and friends in the South of France. Arthur Hahnloser is accompanied by his wife Hédy (with the dog), and daughter Lisa is seen at an unflattering proximity. Their descendant Margrit Hahnloser-Ingrid has written (in S. H. Newman, 1984) a detailed account of the development of the painting that is revealing about Bonnard's slow, hesitant working processes. She relates how he offered it up for public exhibition but afterwards took it away for further work, exclaiming 'Seldom have I bungled anything so completely. All one sees is the white of the sail.' He came back with the canvas months later and asked his friends to judge how much he had altered the size of the sail. Some hazarded that it might have retreated by as much as six inches, at which Bonnard disclosed that in fact no measurements had changed; it was merely that the colours, particularly the blues of the sea, had gained in intensity. 'The effect of colour alters the proportions completely. This was a surprise and a lesson to me.'

Even after finally parting with the canvas, Bonnard was not finished with the image; being given a photograph of his work, he pencilled further hatchings and outlines on top, the better to define it.

c.1924. Oil on canvas, 106 x 96 cm. Private collection

Marthe, according to Annette Vaillant (1965), 'always felt the need to lather herself, scrub herself and massage herself with a sort of meticulous sensuousness, for hours on end... The only luxury she ever longed for was a real bathroom with running water.' This luxury, after its installation at Ma Roulotte and later at Le Cannet, became the inner sanctum of the couple's domesticity, and as such the central location of Bonnard's art. In its steamy confines his sensuality could collude in indefinite variations with her obsessionality. The mid-1920s, the time of their belated marriage, saw a particularly extended series of paintings exploring ways of clutching at her closeness.

This example, more obviously than those which follow it, is indebted to Bonnard's chief forerunner among the soap and sponges, Degas. It was an influence that had been particularly strong in Bonnard's nudes of the war years (see Fig. 24), when he was concerned to give a firm backbone of draughtsmanship to his painting. Like Degas, Bonnard is drawn to the impromptu knots in which the body momentarily and unconsciously ties itself. But unlike the cold-eyed bachelor, he allows a comfortable familiarity about the woman's body to temper the sharp observation. Also a certain degree of memory, of fond idealization perhaps, if one considers that Marthe at the time of painting was in her late forties; that her contours would remain unchanged in paintings done a decade later; and that even after her death Bonnard would continue to work up images of the same slim form.

Fig. 27
Study of Nude
c.1924. Pencil,
24.8 x 32.8 cm.
Private collection

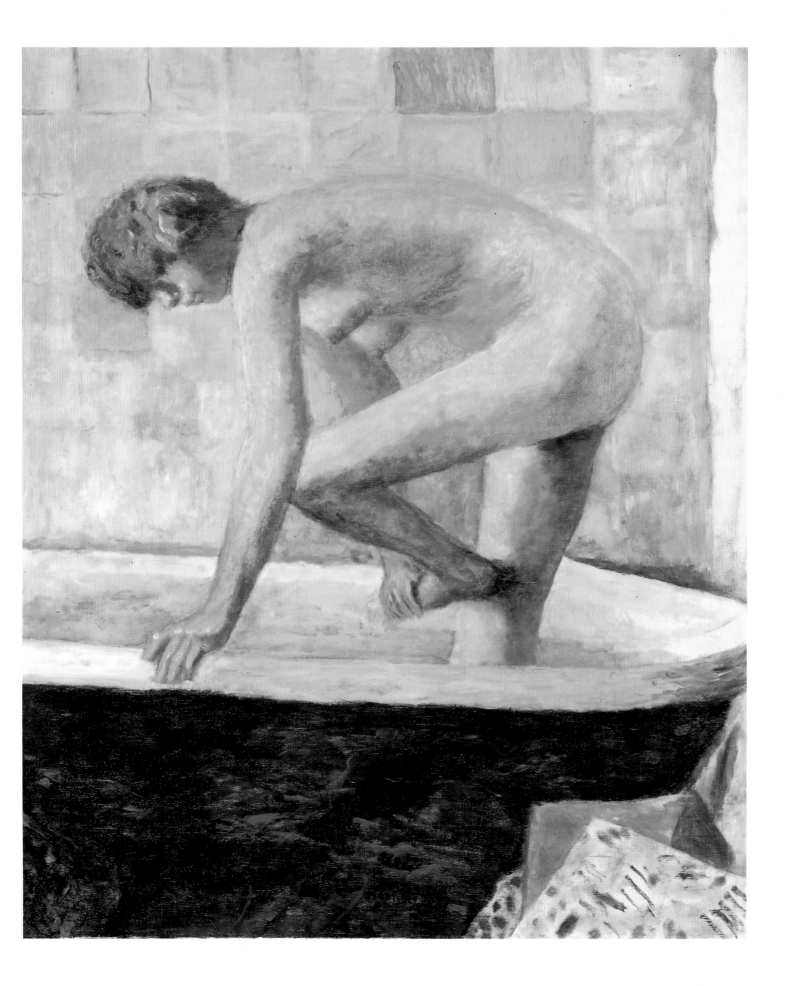

Nude, Right Leg Raised

1924. Oil on canvas, 74 x 78 cm. Private collection

In contrast to the muted tones of the *Pink Nude* (Plate 32), the daylight in this painting has been squeezed for all it can yield of gold, pink and mauve-blue. Bonnard has followed principles similar to those he outlines in discussing landscape (Plate 29): 'One thing is necessary in painting: heightening the tone.' It is necessary because 'one must think of the place where the canvas will be seen afterwards'. He goes on to add, with a fascination for the effects of unselfconscious art that goes back to what he learned from Gauguin: 'Primitive painters had understood this, clearly, for they derived their brightest reds and blues from precious colourings: lapis lazuli, gold and cochineal.'

On first impression the subject seems to have been painted for the sake of that turn in the body's volume from blue to gold, with the back's glistening highlights. But the colour is beyond that a register of the body's almost smellable nearness, which also determines the foreshortenings of the drawing. Around that obsessive proximity chance fragments of the bathroom collect themselves. All sense of the room as a space in its own right – the element so important in earlier work such as the *Nude against Daylight* (Plate 13) – disappears, leaving only anomalous details like the red and white mat. Everything has been concentrated on the effort to get close, as if thereby the paint and the subject could somehow be aligned.

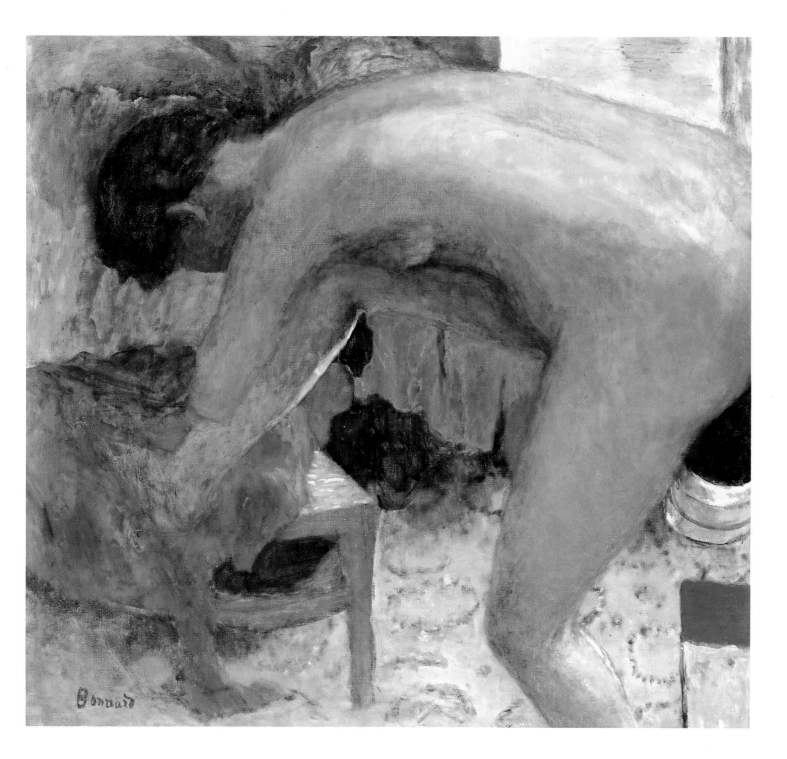

1924. Oil on canvas, 101 x 73 cm. Bernheim-Jeune, Paris

This is a further study of Marthe tending her toes with her back to the right, like Plates 32 and 33, but the most feathery, shimmering and ambiguous of the series. The mystery obviously obtrudes in that lower leg. It is drawn as if seen by its owner, but given a feminine appearance. Are we to imagine Bonnard resting his sketchbook on Marthe's shoulder as she sits robed after the bath and looking down; doing his best not only to see her, but to be her? How would it be to possess his woman's body, in all senses? Since such unity is evidently unattainable, he lets the effort pass over into a bemusing bizarrerie, dwelling on the patterned floor and blue back screen.

Bonnard's relations with his abiding model are nowhere better examined than in the novel *Contre-jour* by Gabriel Josipovici, which meditates on the differing qualities of their needs for each other, firstly through the imaginary eyes of the child they never had, then through Marthe's own distressed vision: a rare case of writing making a fully fitting and equivalent response to the painting. The nudes painted after the mid-1920s retreat somewhat from the passionate claustrophobia of this series: the bathroom itself again becomes a factor in the composition, though it is increasingly transmogrified into a glittering jewel-chamber.

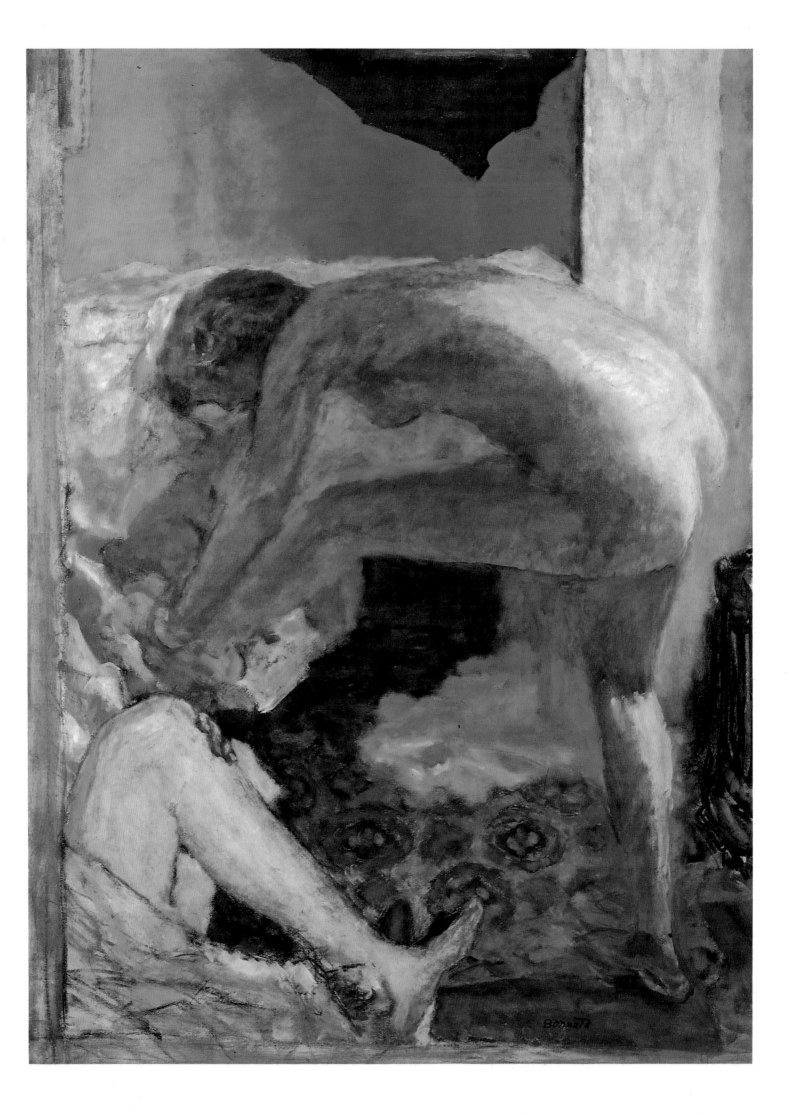

The Bath

1925. Oil on canvas, 86 x 120 cm. Tate Gallery, London

Fig. 28
The Bath
1925. Lithograph in black,
33 x 22.5 cm

The uncompromising simplicity of this painting makes it one of Bonnard's most memorable images. He has taken on a figure subject with the compositional qualities of a Lowlands landscape – virtually nothing but horizontals, five unbroken zones each with a separate hue – and held it together through the sheer intensity of his gaze. The painting shows the gathering stride and unprecedented daring of Bonnard's work in his late fifties: the vertical strips that composed *The Open Window* (Plate 27) were notched together by little incidents of cast light, but here the light flickers and fluctuates almost evenly everywhere, making a slight gathering towards a highlight on the enamel a major event. Caught in this monotonous shimmer, the woman's head takes on an impassivity like that of her flesh and, strangely for once, the painting becomes a psychological account of her state – of what it's like to be her: numb, diffused, half washed away. (What is it like to become a painted object?) Bonnard's physical closeness to Marthe is gently acknowledged in the recession of the lines away from the head; but more than that a spiritual closeness seems to underlie these most famous of his images, in which he creates a pictorial analogue for her own harried quest for serenity and nullification. The orange margin at the base is where the picture, originally worked at within the confines of a larger stretch of canvas, turned out when stretched not to be rectangular and needed filling.

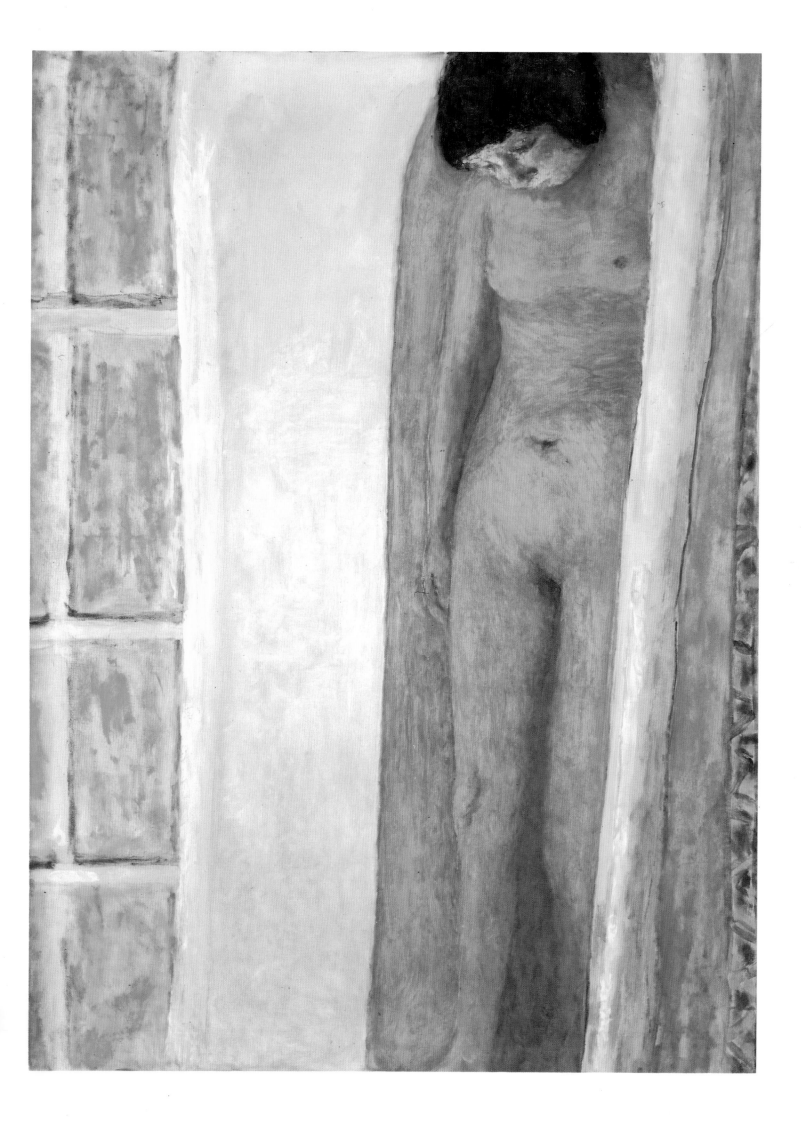

The Palm

1926. Oil on canvas, 114.3 x 147 cm. Phillips Collection, Washington, DC

Visual paradoxes become meat and drink to Bonnard during the 1920s – here the paradox is that the foreground figure who fixes the scene, staring out from it directly, is described in a pallor bluer than the far distance beneath the palm frond. The screen of incidental detail that comes between these wan spatial polarities is a jumble of ferociously red-hot roofs. Attracted by the conceit of thus reversing normal pictorial expectation, Bonnard has made good one of his most majestic compositions. The sense of the painting skirts close, however, to tourist-brochure banality – welcome to the happy South! – whose denizens, on close inspection, can be seen beneath their dwellings: it does after all come from one of the enthusiastic northern immigrants whose chalets and bungalows were increasingly sprawling over the sunlit slopes of the Côte d'Azur. But despite her apple of promise, the girl with the steady, inscrutable regard is wrong for a career in advertising. She bears too heavy a weight of mixed cultural memories, with their potential for ambiguity and melancholy.

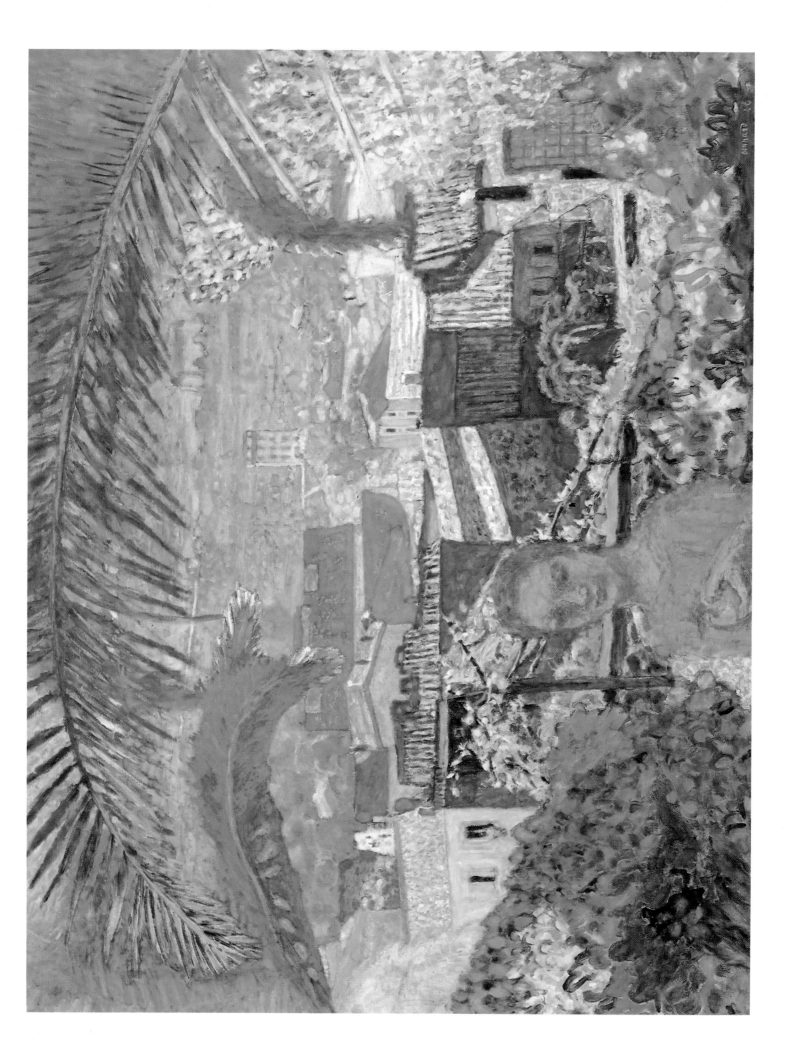

Getting Out of the Bath

c.1926-30. Oil on canvas, 129 x 123 cm. Private collection

As if Bonnard had set himself to meet the theme of movement head on: generally his bathers are occupied with something steady and repetitive, for example scrubbing or drying, but here one great bound forward has been seized on and translated with a Matisse-like simplicity of line. Her hurtle and the corresponding recession of the bath are equipoised against the flattened checkers of the tiling, which affirm that this is a flat painted surface and that nothing at all is actually going to move: a resistance to illusionistic dramatics that dates from Bonnard's early days as a Nabi. The tension between receding perspective and the wish to display decoratively and flatly has led to a tussle in the drawing of the corner table. The bathroom has become a laboratory, in which known quantities like mats and towelling can be ticked off with a summary sign-language. Fig. 29 is an example of his continued musings on the subject.

Fig. 29
Standing Nude, with
Head of Artist
1930. Charcoal,
60.3 x 45.7 cm.
Private collection

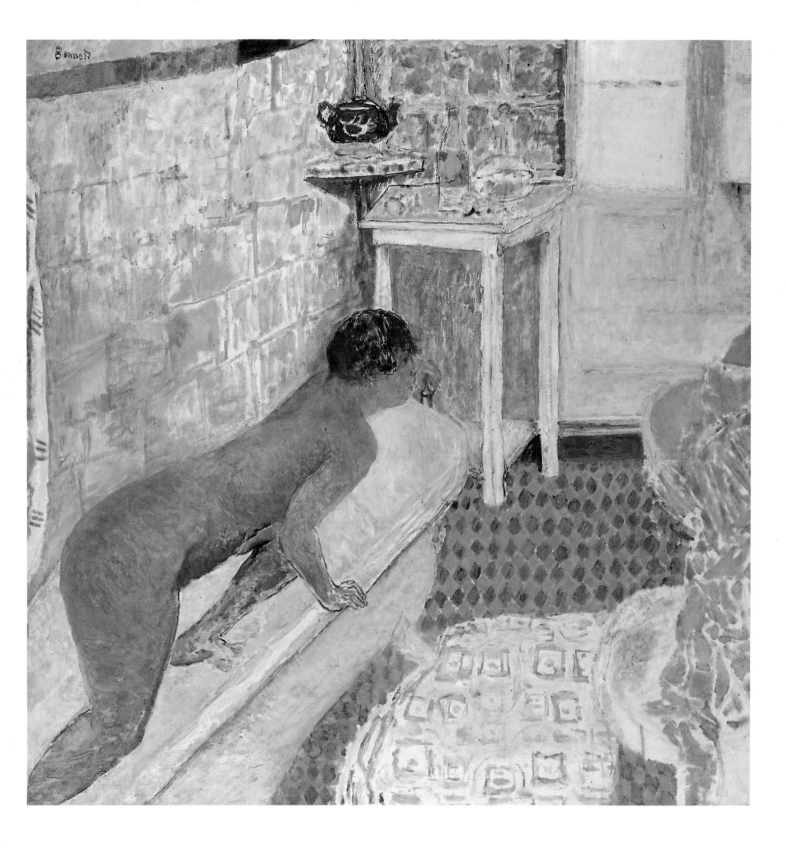

Landscape at Le Cannet

1928. Oil on canvas, 123 x 275 cm. Galerie Maeght, Paris

Bonnard's sixties seem to have brought to him an assurance of power and capacity – hence this grandiose summation (nearly three metres wide) of his adopted land of the Côte d'Azur. The view is from the hill above his house, Le Bosquet, looking down on its orange roof to the central left and the intense red of Le Cannet's roofs beyond it, all subsumed within the landscape's heavy natural folds. The breadth belongs to a travelling gaze – nearly 180 degrees are encompassed by the view, leading its lines to wander in slowly swaying curves. Perhaps an analogue for this type of painting is Monet's *Waterlilies*, painted in the decade before this and likewise offering a panoramic experience in which the eye is half held still by particular incidents of the brushwork, half dragged onwards by the shifting of the field. Bonnard was in contact with the older painter while in northern France, and would wait with some trepidation for his nod of approval on studio visits. However, he also reported his generation's reservations about Impressionism: 'We were more strict as regards composition'. Here he emphatically closes off the wide field with the bizarre red calf and black branch at one end and at the other the lanky pastoral figure who seems to hold the whole landscape behind him within his dreaming head.

1930-31. Oil on canvas, 159.6 x 113.8 cm. Museum of Modern Art, New York

Using a window as the fulcrum on which to build up a composition, yoking together inner and outer, was habitual to Bonnard from the 1910s. With this canvas of his late maturity it has become second nature to make the décor within and the view beyond a continuous field for exploration. But asserting his independence from the window's four-squareness, he has stationed himself to its right and gently, not stridently, plotted his drawing to allude to this fact of personal situation, while also defusing the orderly recession suggested by his high viewpoint through the playful crazing of the shutter-slats. The whole scene is brought together through a repeated accent on slaty blues and golden browns. These hues, contrasted to the shimmering oranges and ceruleans of the Côte d'Azur, place the painting as a memory of Arcachon in southwest France, one of the resorts to which Marthe's quest for healthy conditions often took the Bonnards during this period. She makes a wraith-like half-appearance on the left, recorded outside the bathroom as the frail, ageing and haunted figure she had become, while the heart of the picture to which the table's lines tend is a vagueness of foliage.

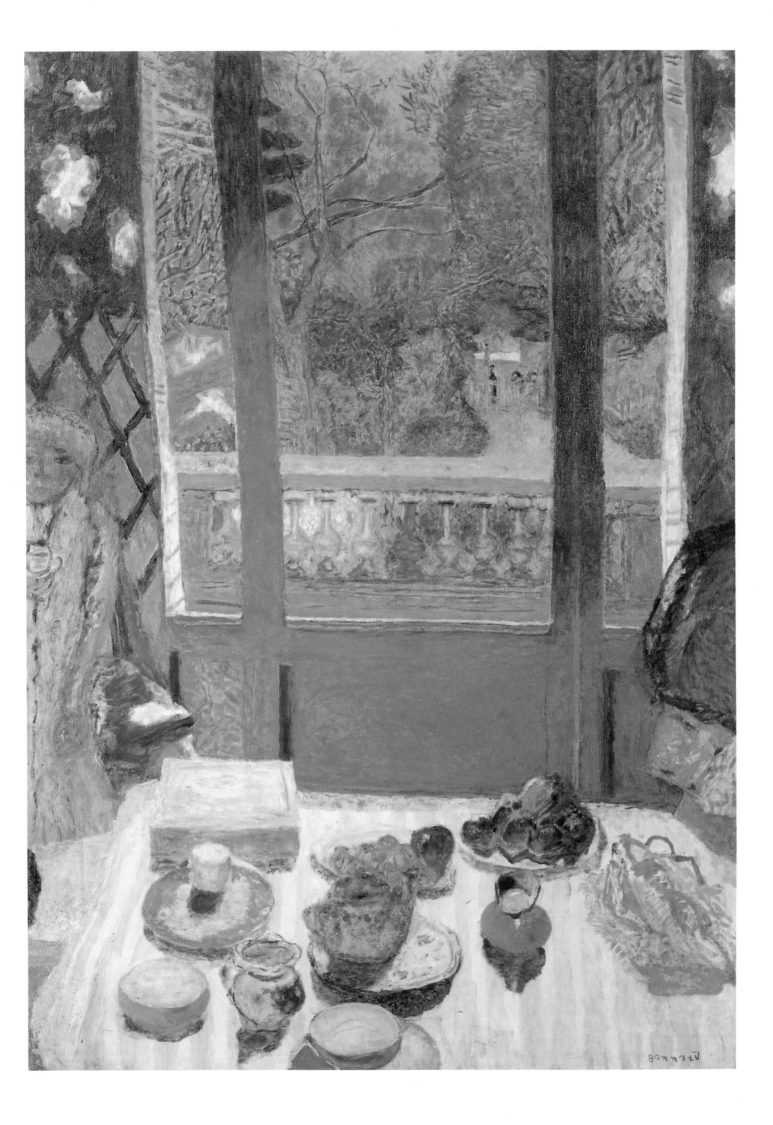

The Boxer

1931. Oil on canvas, 54 x 74 cm. Private collection

A self-portrait; painting, or the canvas, as the adversary. I go at him, I give it all I can, but he is the stronger and (as Bonnard said elsewhere) 'I am very weak'; yet that is my hire, that is my life; a clown, a fool.

Bonnard once again reaches for something right at the furthest extent of his grasp, and his tragicomic losing punch hits home. The emotionality of his self-exposure, the viscerally expressive colour go beyond anything he had attempted previously: the nearest comparison is to the raw tremulousness of Titian's late paintings, although Bonnard in his intent modesty would reject any comparisons to the painter he most revered. What in particular occasioned the analogy, recorded in a couple of sketches in his diary, between his own features and those of a black pugilist seen perhaps in the sports pages becomes irrelevant. The only qualification of the stark distress is the edge of mirror recorded on the right. But the painting wins; though the man goes down.

41 White Interior

1932. Oil on canvas, 109 x 156.5 cm. Musée de Grenoble, Grenoble

Most commonly in the late twentieth century 'art' is an experience of reproductions in formats such as this book, offering ready, compact images for mental filing. But even when reduced to such a scale this large canvas refuses to offer a quick imaginative take-away. Rather, with its slowly evolving articulated structure, its disquieting key changes and shifts in tempo, its willingness to dwell on emptiness, it offers an experience that might best be compared to early twentieth-century chamber music such as Bartók's. The attention makes a protracted series of tumbles from the red sky down to the black fireplace, and up again in a coda to the viridian vase. The subject of the picture becomes this sequential descent, hinged temporally by the big baleful door. The clashing angles of the drawing retard that progress, while the curve of Marthe's back shoehorns it. The consummate boldness of Bonnard's conception appears in the reprise of the table – it was like this; or rather, it was like this – a device which may have behind it the Cubism that had alienated him in its initial appearance, but which here serves as part of a personal meditation on the passage of experience.

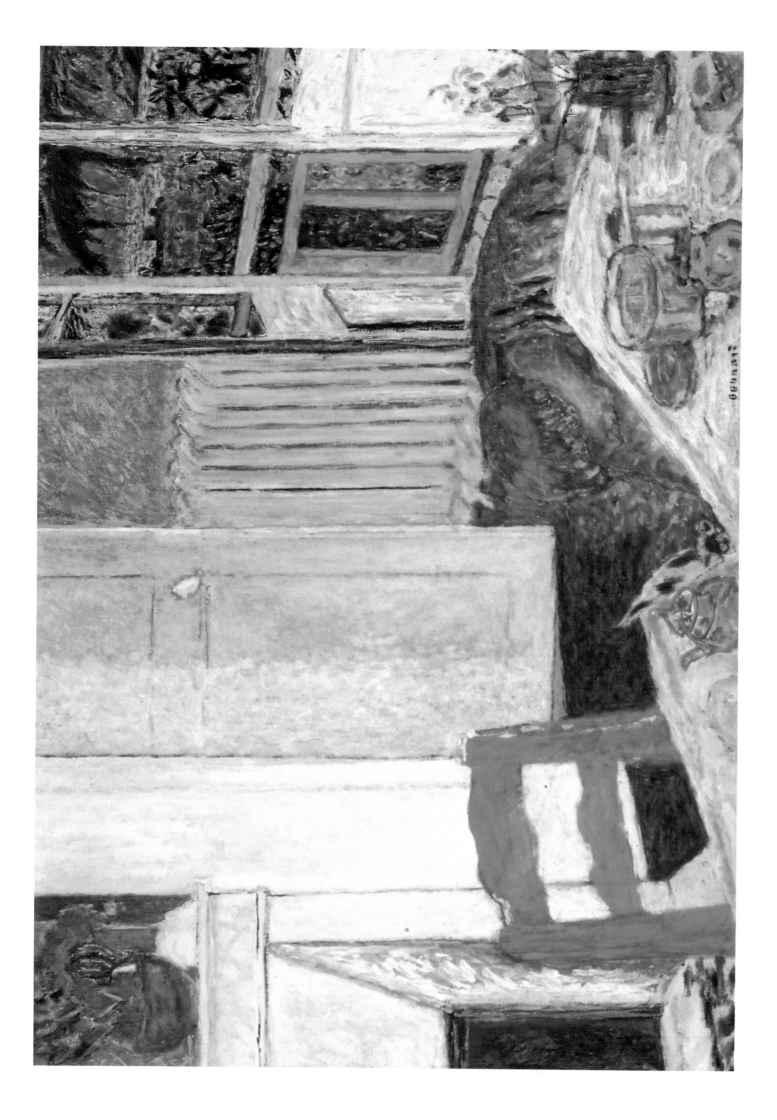

Nude in the Bath

1936. Oil on canvas, 93 x 147 cm. Musée du Petit Palais, Paris

Bonnard spoke of this as one of the most challenging compositions he ever attempted: 'Never again shall I dare to tackle so difficult a motif. Though I have been working on it for six months, I can't manage to get what I'm after, and I foresee several months' work ahead,' he told a journalist who obtained a rare interview in 1937. What were the problems that demanded these labours, with their manifestly extraordinary results? Again Bonnard is tackling the horizontal zones presented by *The Bath* of 1925 (Plate 35) – wall, enamel, woman-in-water, enamel – although here (in a different bathroom) he has the added complexity of a mirror and more space in which to move around and emphasize his own position in the drawing. But the given horizontals are crossed by a scattered fall of sunlight. The crucial decision of the painting is to treat that immaterial radiance as a subject equal in weight to the fluid and solid elements of the bathroom – to do justice to each of those factors, to reconcile them and at the same time to serve the interests of the picture itself as an autonomous patterned surface. ('They always talk of surrendering to nature. There is also such a thing as surrendering to the picture.') Tugged in these diverging directions, the bathtub buckles and dissolves, taking the woman's individuality with it, in a host of bizarre but unassailable transmutations. In the process, Bonnard hits on the seam of primal yellow that will serve in his last decade as a way of clutching at the light of nature through paint. He has left behind the explicit myth-making of his forties and fifties, but the power of this image is partly that of the ancient story of Danae and the shower of gold.

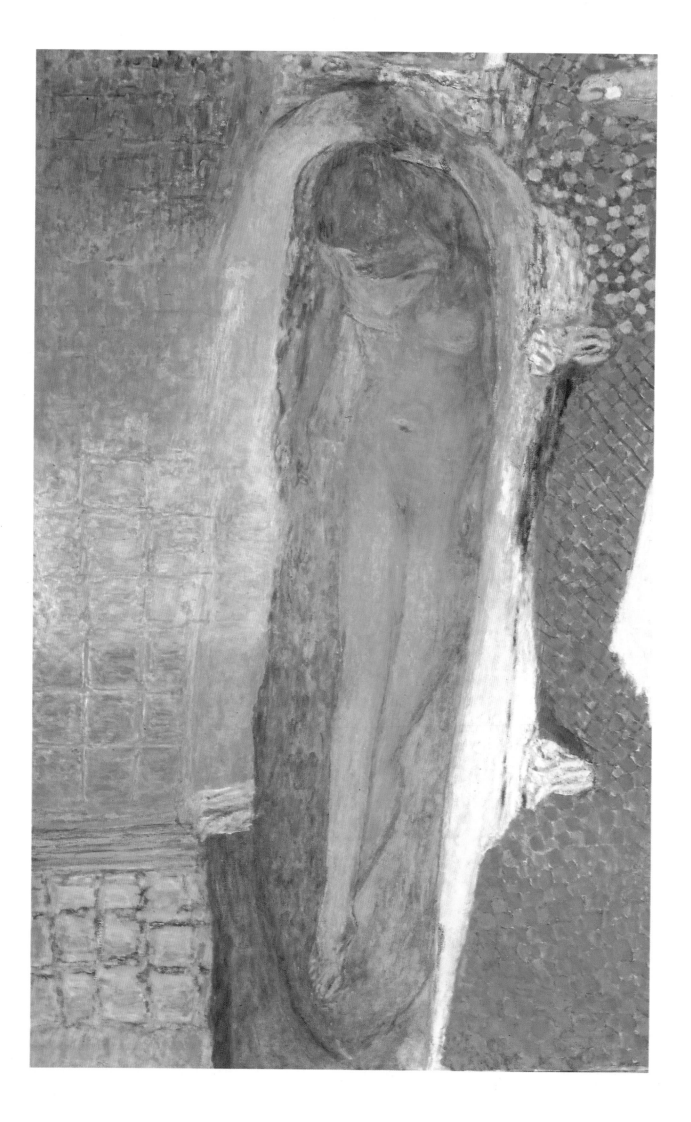

The Garden

c.1936. Oil on canvas, 127 x 100 cm. Musée du Petit Palais, Paris

Occasional paintings from the late 1920s show Bonnard throwing over all attempts to draw objects within the received traditions of perspective, and the work from the mid-1930s increasingly paints a world where objects sketched with child-like preconception sit side by side, attendant on the painter. What comes to matter is their role as containers for visibility – their fruits of colour waiting for his plucking. The sky contains that sort of richness just in the same way, this painting seems to suggest, as the rose and the bushes and the birds and the path: they are all on the same plane, insofar as they are things-of-colour.

This shift of attitude in Bonnard's late work results in pictures governed by an unremitting determination to make every passage work autonomously as paint. This ambition has been echoed, often with acknowledgment, by abstract painters ranging from Nicolas de Stael to Gillian Ayres. At the same time there is a tension in the Bonnard which is absent from entirely figureless paintings: the yellow path and jutting bluish stem tease us with expectations that there is a perspective of foreground and background to be discerned, leading us on into a heady hot vegetal confusion in which those expectations lose their meaning.

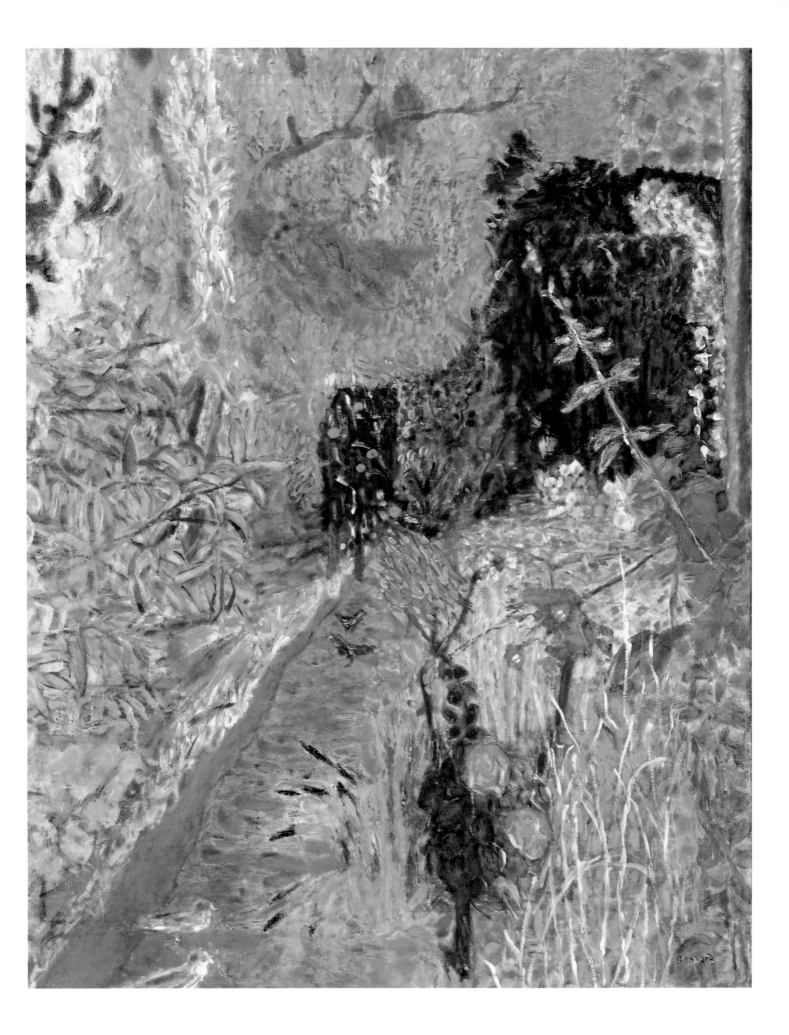

Basket and Plate of Fruit on a Red-checkered Tablecloth

c.1939. Oil on canvas, 58.4 x 58.4 cm. Art Institute of Chicago, Chicago, IL

Still life was a staple of Bonnard's work from the time he sought to prove himself as a producer of saleable oils working for the Bernheim-Jeunes in the 1900s. His catalogue raisonné lists scores of little canvases attending to arrangements of fruit, bottles and the like: often unassuming, five-finger-exercise work. Characteristically the table-top on which they are laid is stretched downwards, flattened out in an overview, with the contents presented upright in their most familiar aspects. This vision of them often seems to have behind it the simple equation, *table* = *tableau*: as if laying a table and painting a picture were both setting forth offerings before a spectator, saying, this is what I should like you to share with me.

The procedure here looks rather like similar conclusions arrived at by Matisse, though there is a muted, quizzical note in the colour that would be alien to Bonnard's assertive friend and neighbour in the Côte d'Azur. Bonnard and Matisse met fairly regularly, as two venerable and mutually venerating old painters, particularly during the Second World War. There is a correspondence between them that opens with a three-word postcard salvo from Matisse, '*Vive la peinture!*'. Natanson relates that whenever Matisse started, with characteristic self-regard, to expatiate on the place held by the two of them in the painting of the twentieth century, Bonnard would shuffle, look down and try his utmost to divert the conversation.

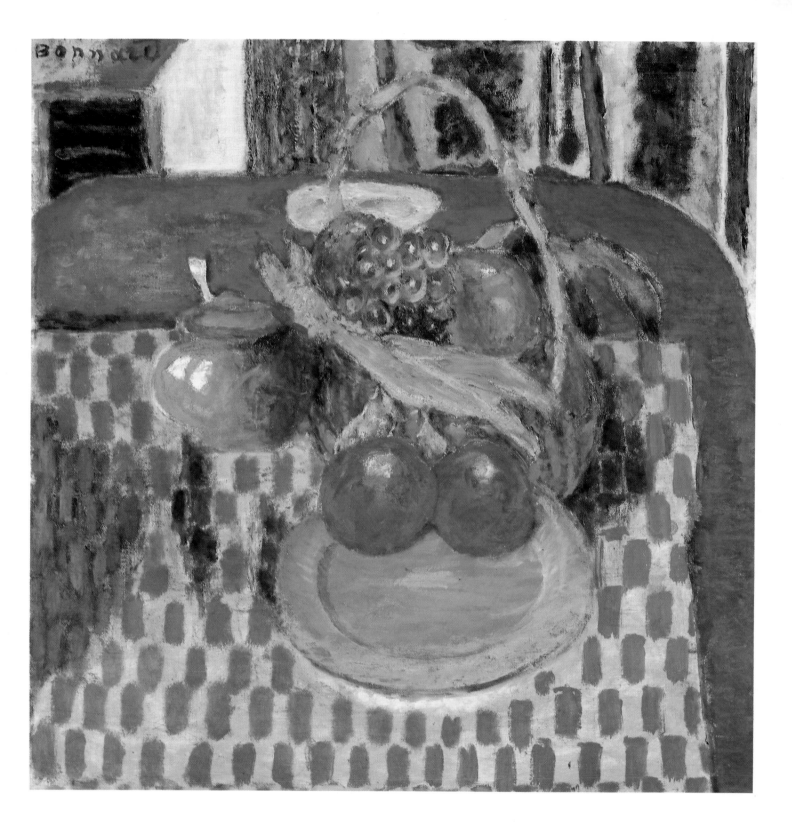

1945. Oil on canvas, 95 x 125 cm. Art Museum, Milwaukee, WI

Bonnard, secluded on the Mediterranean coast for the duration of the Second World War, revisited Paris in 1945 and re-encountered old friends who had survived. Vuillard and Roussel were gone, Natanson would outlive him to publish a long memoir of him, younger men such as the Dauberville brothers who were to produce his catalogue raisonné looked up to him with reverence. Staying in a hotel near the Gare St Lazare, he looked down from his third-floor window on the Parisians rushing about below and noted beside a drawing, 'Brave little people! I love them with all my heart.'

If there is such a thing as a lofty serenity of old age, this painting, done back in Le Cannet where he was cared for by his niece Renée Terrasse, could be seen to embody it in its setting of working man and woman within a large land of plenty. As with many works of the time, Bonnard refers repeatedly to the yellow that seemed to represent the heart of visibility's richness (see also Fig. 30, *Bay of Saint-Tropez*). But there are also fresh coloristic explorations in the shimmering pinks and *terre vertes*. Bonnard remained too restless, perhaps, to be truly serene: writing to Matisse during this period, he described the context in which this work might have arisen: 'In my morning walks I amuse myself by defining different conceptions of landscapes – "space" landscape, intimate landscape, decorative landscape, etc... But in vision each day I see different things – the sky, the objects, all changes continually, one could drown in it. But it makes for life.'

Fig. 30
Bay of Saint-Tropez
1937. Oil on canvas,
41 x 68 cm.
Musée Toulouse-Lautrec,
Albi

Dark Nude

1939-46. Oil on canvas, 81 x 65 cm. Private collection

The model for this painting was Dina Vierny, who posed regularly for the sculptor Aristide Maillol – another artist stemming originally from the Nabi milieu – and for Matisse. She first sat to Bonnard for this painting in 1939 but the main work of this picture was done in the years after Marthe's death in 1942. She recalls Bonnard greeting her nervously and working silently, though sometimes choosing to talk afterwards, outside in his garden. The sessions were an unusual experience for her: 'He didn't want me to stay still, what he wanted was movement: he asked me to "live" in front of him, trying to forget him. At once he wanted life and absence' (*Hommage à Bonnard*, 1986). That phrase seems unimprovable: Bonnard is both keenly aware of the particular strong, dark body before him, with its insistent volumes and lines, and at the same time looks as it were through it to something beyond the life and the person – to the light it depends on, in common with the whole visual field, a community expressed by the strips of iridescent mauve.

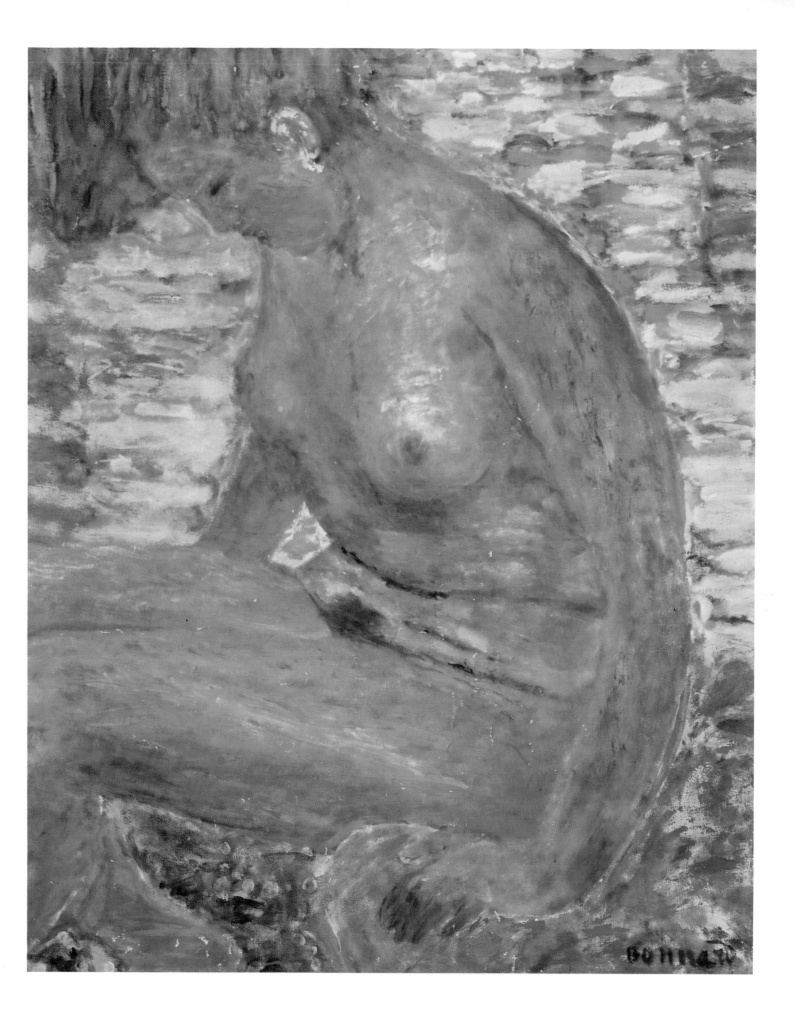

47 Self-portrait

1945. Oil on canvas, 56 x 46 cm. Private collection

Three self-portraits were painted in 1945: the other two are hotter in colour than this, less Decemberish. The date of death throws a retrospective shadow over everything done in its approach, and we tend to read a mortal significance into things that were in fact the business of a living day, done with dinner and bills to think of; still, there's no avoiding the feeling of finality here. The golden yellow of recent work has withdrawn from the scene, the sky through the back window has lost its power to radiate, and the eyes, which are 'the light of the body' (Matthew 6:22), have undergone something like a mutilation. That dramatic gesture, and the softly stated sweep of the curtain calling up memories of Titian portraits, seem to come from an expressionist artist hiding behind the 'late Impressionist' Bonnard sometimes described himself as. It is a strand emerging in earlier self-portraits such as *The Boxer* (Plate 40) and also in the weird and baleful *The Circus Horse* (Fig. 31), an image begun in 1936 but not completed until shortly before Bonnard's death.

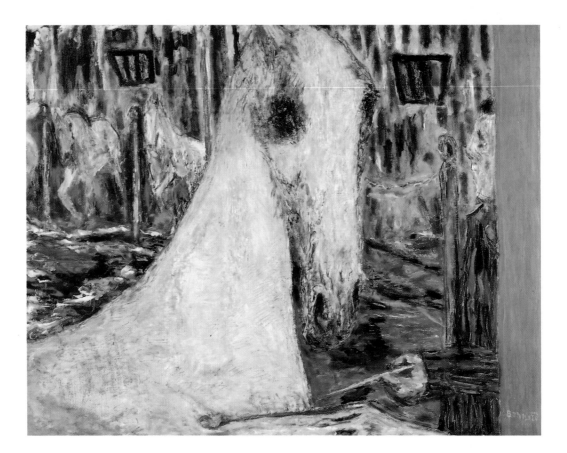

Fig. 31
The Circus Horse
1936. Oil on canvas,
94 x 118 cm.
Private collection

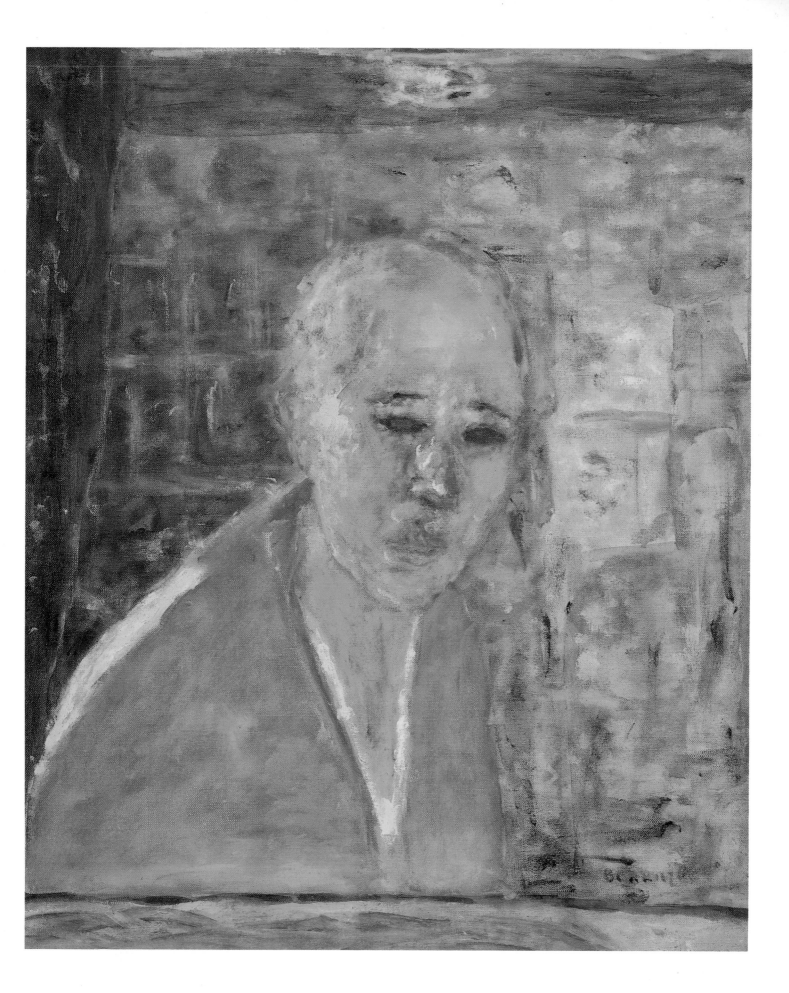

1939-46. Oil on canvas, 127 x 127 cm. Musée National d'Art Moderne, Paris

Fig. 32
Photographs of Pierre
Bonnard and his
studio at Le Cannet
c.1945

Work on this, as on several of Bonnard's canvases, was interrupted during the Second World War, and its completion in 1946 makes it the last of his large-scale works. The view looks down through the railings of Bonnard's workroom and the frames of the window below, stretching to the village of Le Cannet and the plains and hills beyond. As in many previous works, such as *The Terrace* (Plate 24), a screen of vegetation set between near and far becomes the principal fascination of the motif: but what distinguishes this late work is that the occluding screen is composed of intense light. The mimosa's yellow is pitched as bright as pigment can go, while gaining in power from a system of hot contrasts. It pins down the crossing recessions of the foreground frames, making their bowed lines seem unavoidable and overriding the tangential human presence on the lower left. The scheme is comparable to that of *The Open Window* (Plate 27), again bearing witness to Bonnard's capacity to wonder at the given light of the visible world.

Along with that reverence, and with the distinctly private, individualist nature of Bonnard's framework of vision, there is an earned pride implicit in the making of large canvases such as this. Bonnard, for all his humility and diffidence, was certainly aware in undertaking work on this scale of a considerable artistic achievement, giving monumental validity to the personal act of seeing. 'I hope that my painting will endure without craquelure,' he wrote in 1946. 'I should like to present myself to the young painters of the year 2000 with the wings of a butterfly.'

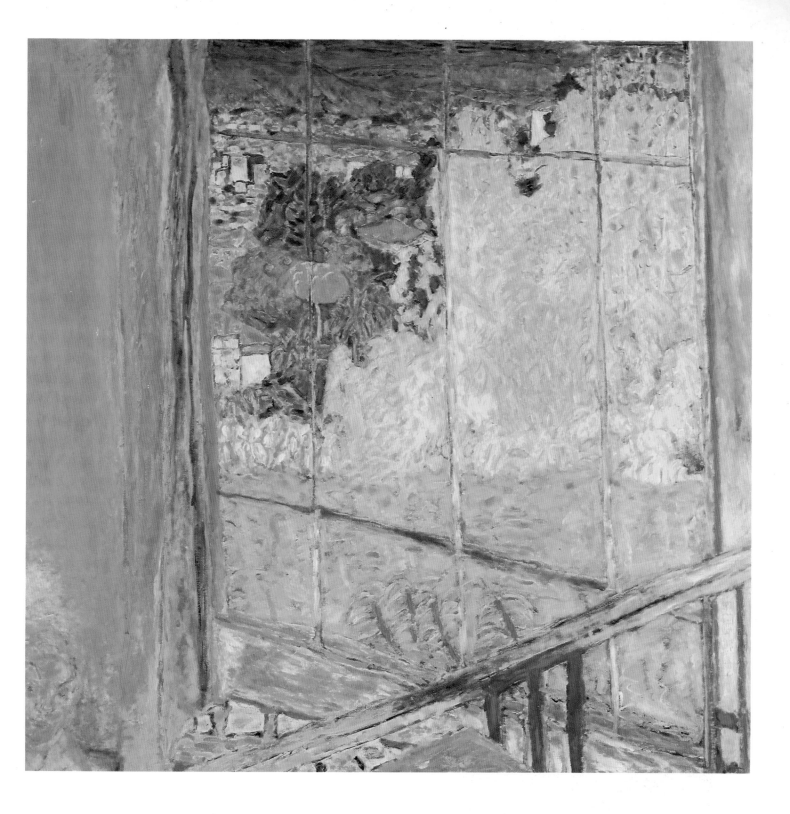

PHAIDON COLOUR LIBRARY

Titles in the series

BONNARD
Julian Bell

BRUEGEL
Keith Roberts

CEZANNE
Catherine Dean

CONSTABLE
John Sunderland

DEGAS
Keith Roberts

DUTCH PAINTING
Christopher Brown

ERNST
Ian Turpin

FRA ANGELICO
Christopher Lloyd

GAUGUIN
Alan Bowness

GOYA
Enriqueta Harris

HOLBEIN
Helen Langdon

IMPRESSIONISM
Mark Powell-Jones

ITALIAN RENAISSANCE PAINTING
Sara Elliott

JAPANESE COLOUR PRINTS
J. Hillier

KLEE
Douglas Hall

MAGRITTE
Richard Calvocoressi

MANET
John Richardson

MATISSE
Nicholas Watkins

MODIGLIANI
Douglas Hall

MONET
John House

MUNCH
John Boulton Smith

PICASSO
Roland Penrose

PISSARRO
Christopher Lloyd

THE PRE-RAPHAELITES
Andrea Rose

REMBRANDT
Michael Kitson

RENOIR
William Gaunt

SISLEY
Richard Shone

SURREALIST PAINTING
Simon Wilson

TOULOUSE-LAUTREC
Edward Lucie-Smith

TURNER
William Gaunt

VAN GOGH
Wilhelm Uhde